Roberto Chavez

Paintings and Drawings

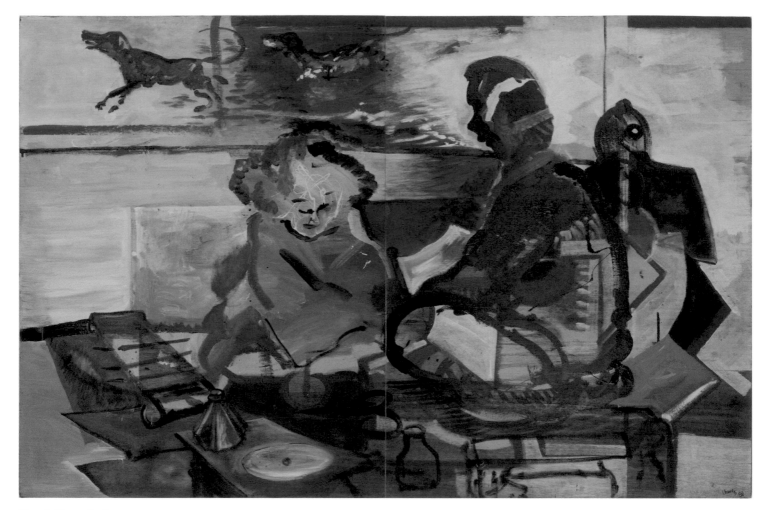

The Calligraphy Lesson
71³/₄" x 48"
Latex on panel
1988

I want to dedicate this book to all my teachers;
from my grandmother Agustina Vasquez to my wife Janet Kassner,
and all those in between, whose counsel and guidance have made my life
a journey full of wonder and discovery for which I am forever grateful.
Without their influence and help this life would have been a truly sorry affair.

Roberto Chavez
MAY, 2012

Roberto Chavez

Paintings and Drawings

Edited by Robert Ross

hit & run press

BERKELEY, CALIFORNIA

hit & run press
1563 Solano Avenue, #379
Berkeley, CA 94707

Manufactured in the United States
FIRST EDITION
ISBN 0-936156-05-7 (CLOTH)
ISBN 0-936156-07-1 (PAPER)

Cover (also on page 52)
Self Portrait with Speedy Gonzales
15½ x 19½
Oil on canvas
1963

Acknowledgments

This volume is published on the occasion of a major traveling exhibit of drawings and paintings by Roberto Chavez.

The originating venue of the exhibit is the Robert F. Agrella Art Gallery of Santa Rosa Junior College, Santa Rosa, California, running 14 November through 15 December, 2012.

Thanks to Renata Breth, Director of the Gallery, for attention to the administrative details. Much gratitude goes to Stephanie Sanchez of the SRJC faculty and gallery staff; without her energetic support, advocacy, grant-writing and gallery experience, the exhibit (and by extension this publication) would not exist. The Randolph Newman Cultural Enrichment Endowment was an early and generous grant donor.

The final venue for this exhibit is the Wiegand Gallery of Notre Dame de Namur University, in Belmont, California, running 23 January through 23 February, 2013.

Robert Poplack, Director of the Gallery, generated and curated this second exhibition. Appreciation to the Wiegand Gallery Advisory Board, members of the Directors Circle, and Notre Dame de Namur University, for their major assistance with the exhibit and the book.

Besides the professionals and institutions mentioned above, many people played significant roles in producing this book. Anatol Chavez, the artist's son, has been an indefatigable archivist of his father's work, and moved both exhibit and book along in so many larger and smaller ways. For careful text-editing, sincere appreciation to Adrienne Ross, a friend of Roberto since Los Angeles City College days, and to Zida Borcich and Mario Ross. Theresa Whitehill of Colored Horse Studios created the efficient and elegant design which makes this book so user-friendly.

Much credit is also due to those who generously offered access to their own carefully developed written resources: Terezita Romo, author and Lead Curator for *Art Along The Hyphen: The Mexican-American Generation*; Chon Noriega, Director of UCLA Chicano Studies Research Center and Co-Curator (with T. Romo and Pilar Tompkins Rivas) of the Getty Foundation's *L.A. Xicano* exhibits, for permissions, introductions, and ongoing encouragement; Rebecca Frazier, Senior Editor at UCLA Chicano Studies Research Center Press, for permission to reprint the Chavez piece "Why Paint?"; Michael Duncan, Curator of the 2012 exhibit *LA RAW* at the Pasadena Museum of California Art; and Gordon Rice, lifelong friend, fellow painter, and LACC and UCLA colleague to Roberto, for his memoir about early days with Chavez.

Immense thanks to Roberto himself and his wife Janet Kassner for long-time friendship, invaluable mentorship, general enthusiasm, and great feedback at all stages. Finally, for sensitive reading of the text, for technical help, and for unflagging patience and support for this important project, the author gratefully acknowledges his wife Ayn Ruymen Ross.

Contents

Foreword

This book presents 68 works by Roberto Chavez. As the reader may readily determine, his approach is dynamic, soulful, painterly, and accomplished. Although samples of his painting appear in gallery and museum catalogs, this is the first extended presentation of his work.

The images reproduced here have been chosen from Chavez' output from the 1950s onward. He's created hundreds of paintings and thousands of drawings. While the present selection is not intended to be a comprehensive inventory, it offers a substantial view of the range and authority of his work.

Chavez is deeply immersed in the history and traditions of art. The scope of his influences is broad, and artists as diverse as Goya, Grosz, Hokusai, Brueghel, and Braque are his familiars. He's absorbed the look and feel of the mixed neighborhood of his youth, and the objects, signs, scapes, and personae of Mexican, European, American, and Japanese cultures. At age sixteen he studied art at Los Angeles City College, and after three years doing photographic work for the U.S. Navy, he took Bachelor's and Master's degrees at UCLA. He's spent his adult life painting, exhibiting, and teaching. The reproductions in this book show a variety of traditional approaches to representation, and inventive and generous combinations and permutations of these. What emerges is a distinctive, mature, and integrated pictorial language.

In addition to the many reproductions, the reader will find writings by Chavez himself, sharing his understanding of art and his own roots as an artist. There are also an introductory essay about the nuts and bolts of his work and a biographical timeline. It is hoped that these offerings will give the reader an accurate sense of his creative life, and inspire a search to view the original works.

The Drawings and Paintings of Roberto Chavez

A great sensuality is instantly apparent in the drawings and paintings of Roberto Chavez. It shows in the varied subject matter and more profoundly in the artist's passion and the devotion with which he handles his materials. These are works deriving from an emotionally rich imagination and a deep love and understanding of art.

Chavez' life and work have followed a path of uncertainty and intuition, a path of interior authenticity. His work is powerful and life-affirming in its celebration of color, of light, of the pure discovery of human meaning and pictorial possibility. That said, much of his work is challenging and even troubling. He stands as witness not only to the world of his imagination, but also to the world we live in.

For artists and viewers alike, there's an important distinction between technical polish and authentic personal connection. For an artist to stay open to all experiences, struggles, quirks, memory, uncertainty, and illumination, and to tap these resources in a deep intuitive way, is to choose a path at odds with Art World trends and politics or the conventions of breadwinning. This has been Roberto's life choice; it's where he's placed himself among the pressures and inducements of our modern social, economic, and political environment. It represents a political position, even more than do his visual depictions of social oppression.

The central artistic wellspring vitalizing all of this work is his life-long love of drawing. Chavez can render in many modes, from highly representational, to cartoon-like, to quick-brush impression, to geometric, to nearly or totally non-representational. The spontaneity and fluidity in the work show his complete trust in his hand. This comes from a firm dedication to the practice of drawing – drawing on whatever materials come to hand, or whatever subjects might present themselves inside or outside the artist's head. This is *all-the-time* drawing. It functions for pleasure and for discovery.

His long-time friend and fellow-painter Gordon Rice writes of Roberto's drawing process:

> We drew constantly. Chavez became a compulsive draftsman, drawing on stir sticks during breaks, paper napkins and styro cups, anything to hand. A stick would become a totem pole, a cup a cylindrical mural study.
>
> Who could draw from memory like Chavez? He did a series of drawings & watercolors on the rioting & looting after the Rodney King beating, a lot remembered from TV footage. He could draw animals from memory. A stretch between cartooning & cubism (& more) helped get out the images he's carried & transmitted.
>
> Memory and work from nature (anything before your eyes) fully inspired Chavez. If you're standing or sitting, walking or driving, if you're with him you're looking. He sees what's there and sees too a myriad of associations, implications, reflections and responses. With careful seeing, remembered imagery becomes as alive as the present.

For Chavez drawing has been a durable and natural practice, similar to yoga or meditation in the sense of being a habitual means to encourage awareness and attention to what is. It's a means to build strength and flexibility and to increase his appreciation of the visual world – the world of nature, of individuals, of societies, of multiple traditions of art; and of color, of form, of light, of invention.

▦

Consistent in his work is deft, spontaneous, and absolutely fearless mark-making. There's magic in this, not unlike what the earliest humans must have experienced scratching a line or circle in the dirt with a stick, or delineating the figures of humans and other animals on cave walls. Paint itself has a vibrant, plastic, sensual attraction. It inspires exuberant brushwork, glops, smushes; it begs to be manipulated, pushed around, gentled, dragged. And this is the material reality of Roberto's painting. The woman who sat for the portrait is not there. Faced with the painting you cannot reach out and touch her. She is not *presented*; she is *re-presented*, she is the *abstract* part. What is *present* and *realistic* is the paint; the marks themselves; the choices of color and value; the scale and rhythm of the composition, and its quality of invention.

From the moodiest portraits to the most cartoonish fantasies, the appeal of the paint is an essential, compelling feature of this work. Something similar obtains in the drawings and watercolors: the physical quality of the material. Much of this can be communicated or at least implied in reproductions. For the full visceral response, it's always best to confront the picture itself, eyes-to-original, preferably without the intervention even

of protective glass. Something unique happens in this confrontation with the real-size thingness of a picture. The viewer has an opportunity to register physically the topologic change of shape of globs of paint as they've left the brush and adhered to the canvas. The possibility arises of understanding that an artist *did* this, moved the paint or pencil around in *this particular way*, handled the brush here with so much pressure and speed and there with a different attack. In Chavez' case this is never the result of a formulaic intention or a practiced technique. (Once, in a painting class, Roberto's students asked him to teach them some "techniques." Following a thoughtful pause he replied: "I don't know any." This was at once a reluctance to encourage shortcuts or tricks, and a true confession.) Even when his aim is to paint a portrait of a specific individual or still life, there are no rules, no guidelines, only the painter's instinct and experience and his appreciation of the suppleness and infinite generosity of the subject and the material.

In 2011 the Getty Foundation sponsored a major exhibit at the Autry Museum in Los Angeles, *Art Along the Hyphen: The Mexican-American Generation*, which included important works by Chavez. Terezita Romo composed an excellent essay for the catalog, and in her preparatory interview with Roberto he reflected on his way of working:

> [William Brice, at UCLA] showed me this Rubens painting. And he pointed out the details in the toenails, and some damn thing. And it sort of brought me down, because I looked at my own paintings, and they were sort of goofy, you know? Because I always felt the freedom and incorporated the freedom of the cartoon – a cartoonish expression. At the same time, nobody was mistaken about what I was trying to draw or paint.
>
> [Brice] made a still life – a big arrangement of shit to paint, and he had included a Japanese kite, a fish creature (*Japanese Fish Kite*, page 6). I worked so hard at it, at some point I realized I was in a different place. I mean, I had always been able to get into my work. But this was different. I touched some really... where your hand is being guided by something that has nothing to do with your brain. It's just, it's doing the right thing, you know? ...and I realized, yeah, that's the place.
>
> With Goya, it's really rooted in people. It's really like it has something to do with the culture, maybe; I don't know for sure. But, he painted things that would have been of interest to me, or that I would have noted. Even painting royalty, he made them look, like, really bizarre. But later on I really got excited by the fact that his paintings, although very representational of a person...they became paint, you know? It was just, pshww! ...alive in its own right. And I have often consciously and often just intuitively given my work that freshness or even roughness to remind the viewer that "This is just paint." "This is just watercolor." "These are brushstrokes." "This is pencil marks." Whatever.

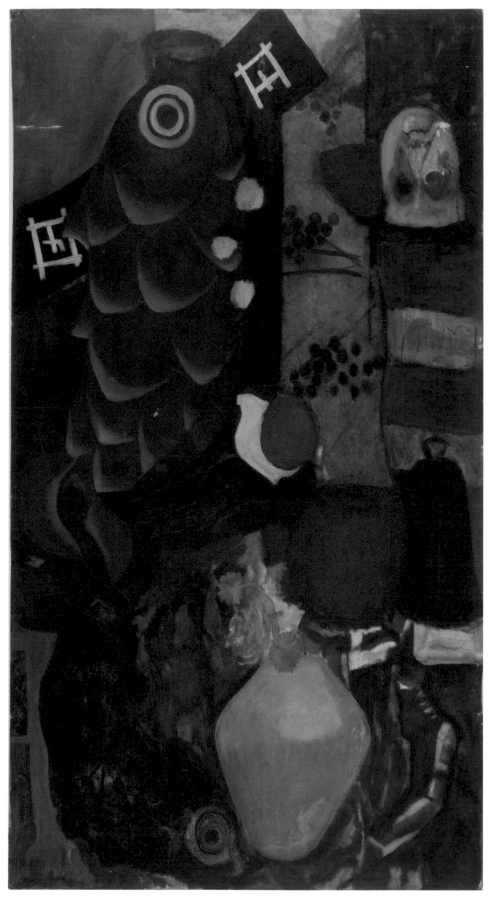

Japanese Fish Kite
29" x 48"
Oil on panel
1956

None of this is to suggest that Chavez' subject matter is merely incidental. In fact, subject matter is fundamental to his work; only a very few pieces are totally non-representational. But it is to insist that what gives these works their essential vivacity is not the subject, but the *treatment of the subject*, the transformation of what's seen and imagined by Chavez into a physical artifact that can be seen and felt by all of us.

▦

As to subject, it's tempting to view the works as relatively discrete categories: portraits, still lifes, street scenes, dogs, mechano-figures, landscapes, political or social coercion, the macabre; and by style, more realistic, more cubistic, etc. This way of looking at his work is handy, but essentially misleading. Chavez often initiates a whole series of paintings on a single general theme or in a similar approach to rendering, all in a period of weeks or months. Some subject or approach will grab his imagination through several explorations, and each subsequent picture can enlarge on or extend what's been suggested and discovered in the previous work. But these series are not necessarily limited to the same mode of rendering. Different subjects or styles seem to coexist with equal availability in his conscious and unconscious life. They mingle in his work in surprising mix-and-match combinations.

A prime example of this is the large tour de force *Still Life with Goose Eggs* (page 8). The drawing in this painting is gorgeous and inventive – loose but genuinely telling draftsmanship. The modeling of the coffeepot, the can, the eggs, the glass, and the skull is simple but absolutely dimensional. While the overall composition is somewhat flattened, in the way of much cubist work, there are genuine depth and form in this painting. The more detailed rendering of the coffeepot and the skull is marvelously integrated with the almost totally abstract geometric shapes surrounding the table. Blended paint appears next to completely flat applications. The whole is balanced, seemingly effortlessly, through thoughtful and surprising uses of shape and color, scale and rhythm. This is not the manifestation of an intentional style. This is the *spontaneous working out of problems arising from the process of painting itself*. The result is as much a display of the artist's memory, imagination, considerable graphic resources, and spontaneity, as it is of a group of objects. He gives us not only the topic and his feeling for the topic, but a clear, accessible demonstration of the dynamics of picture-making. And it is these pictorial choices and adjustments which generate the sense of a coherent and beguiling subject.

In this painting, the use of cubist devices – transparencies, fractured planes, and other, more enigmatic geometry – absolutely influences the overall character and mood of the picture. So does his blazing saturated color, played against neutral tones. The bold spectral color tempered by more chromatic or mixed color hints of the gaily-painted facades of buildings in Mexico, or of comic books, or of the Fauves. His color choices

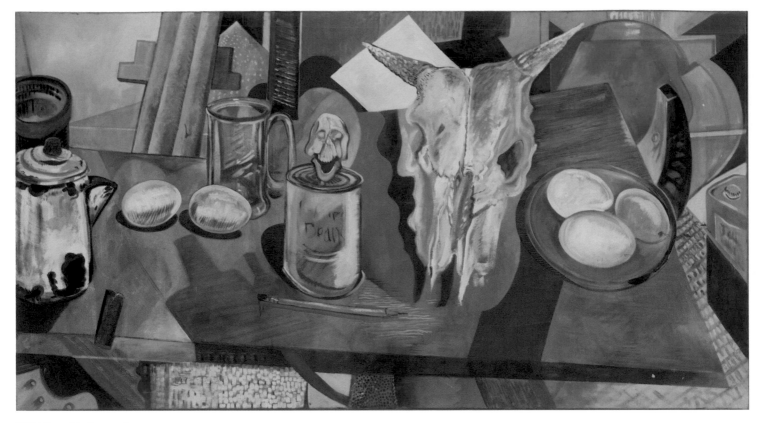

Still Life with Goose Eggs
78⅜" x 42¾"
Oil on canvas
1981
Collection Larry and Meryl Rafferty

are sophisticated, nuanced across the canvas, adjusted both for hue and for value to create a dynamic rhythm, at once mellow and staccato, an exercise of intuition and improvisation building to a beautiful, distinguished, and integrated whole.

Roberto's major painting *Jealousy or Guilt (The Tale of Genji)* is another example of how intuitive process results in pictorial permutation and combination. The painting refers to the Japanese classic *Tale of Genji*. Here again we see the artist's choices for rhythm and invention. Again we see fractured planes and mysteriously interlocking spaces, reminiscent of Cubism, of classic Japanese prints and kimono design, and of the imaginative transitions of (for example) 20th century Mexican mural painting. And the juxtaposition of figures both classic and modern is equally mysterious and stimulating. The conventional Japanese objects – costumes, weapons, screens, fan, lantern, etc. – are played against the unexpected appearance of a camera; the traditionally-garbed witnesses to the macabre and violent scene are played against the image of the photographer, and indeed against the sense of Chavez himself as painter/witness. The color is

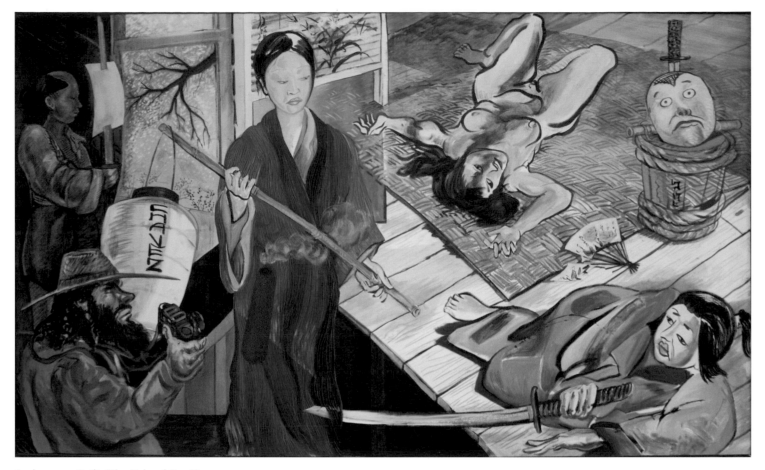

Jealousy or Guilt (The Tale of Genji)
180" x 84"
Oil on canvas
1979
Collection Bill and Lyn Norton

opulent, surprising, and yet carefully considered to make a lively and connected composition. The brushwork itself is detailed but confidently loose. The picture suggests a story but the graphic devices are not tied to literal observable reality. The graphic events derive from the play of Roberto's total sensibility, an organic flowing from the rich, cultivated influences of his life: literature, history, music, art, memory, imagination, improvisation, passion.

Similar processes show up in Chavez' prolific portraiture. Different pictorial devices obtain from work to work; again, an improvisational response to opportunities arising out of the progress of the painting or drawing itself. But a common dynamic in his portraiture is the intimacy of the pictures – the inescapable sense that Roberto has a genuine *relationship* with the sitter, that there's a personal engagement. Not all the portraits are flattering, but all of them (despite considerable variation in paint-handling) have a feeling of truth.

It's said about arrows (as in 'bows and arrows'), that if the arrow is really straight from the core, the arrow 'has true.' Roberto's portraits – indeed all his works – 'have true,' and it is from this internal connection that the quality of intimacy arises. There's a deep core authenticity to his vision which includes, but goes beyond, what his eyes see. It also includes his own complex humanity and his understanding that all humans are complex. Even when we detect irony in the portrait, the irony is not about art itself – it's not self-conscious or self-referential – but derives from *the complexity of the subject*. And even the sketchiest or least-elaborated portraits project a sense of compassion, for the sitter and for our confused species. This felt or 'soulful' aspect of his work is communicated instantly (if unconsciously) to the viewer, *because it is there*. It is somehow, miraculously, transmitted through the sheer physical color-mixing and brushwork and trial-and-error of picture-making. This is the miracle that distinguishes great art from skillful representation.

Speaking about vision is risky. It would be presumptuous to characterize or formulate someone else's vision. It's always personal, quirky, and ultimately subtle and unpredictable in its morphings. But there are aspects of vision which bear mention relative to Chavez' work: observation, witness, voyeurism, discernment.

In his unsettling painting *The Lecher* we can see elements of all of these. The old lecher in the painting is represented as at least a voyeur. Yet there's something voyeuristic in Roberto's rendering as well.... not necessarily a sleazy view, but a recognition of the genuine sexuality in the childish lollipop and short dress playing against the high-heeled shoes, the coquettish expression, and the ambiguity of the female's age. Maybe it's not too much of a stretch to say there's a voyeurism in the envisioning of the lecher as well, an old, overweight guy in shorts, the dumpy posture, the thick calves, even the blue socks, a voyeuristic sense of *his* flawed humanity. A kind of tense and guilty atmosphere pervades the scene, and the power of the mood suggests that in order to paint this the artist must *recognize* it, in the same way a really good actor must recognize in himself the venality of the character he plays. This is not a moral judgment on the artist, but an observation of the deep levels of his discernment.

In Chavez' landscapes, street scenes, and explosively in his depictions of war, racism, poverty, and other crimes, the viewer is privy to the artist's comprehensive function of witness. Repeating Gordon Rice's words: "He sees what's there and sees too a myriad of associations, implications, reflections and responses." This deep witness is not just visual but also visceral: Chavez transforms into pictures his feelings of love, of pleasure in light and color; of grief, anger, skepticism; of irony, of bafflement, of outright amusement, of generosity, of mystery, of truth. These human powers are essential components of his beautiful and not-beautiful works. In the

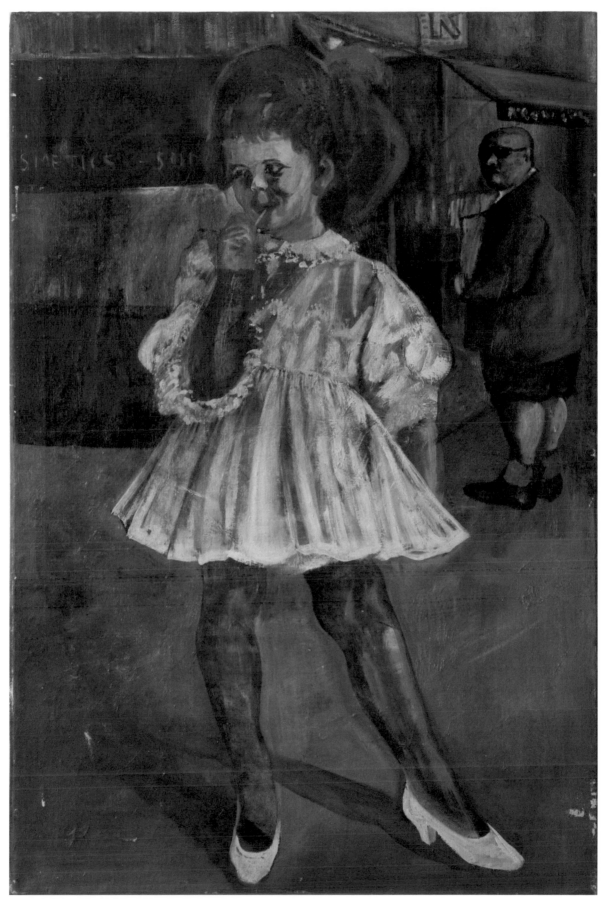

The Lecher
30″ x 45⅛″
Oil on canvas
1965

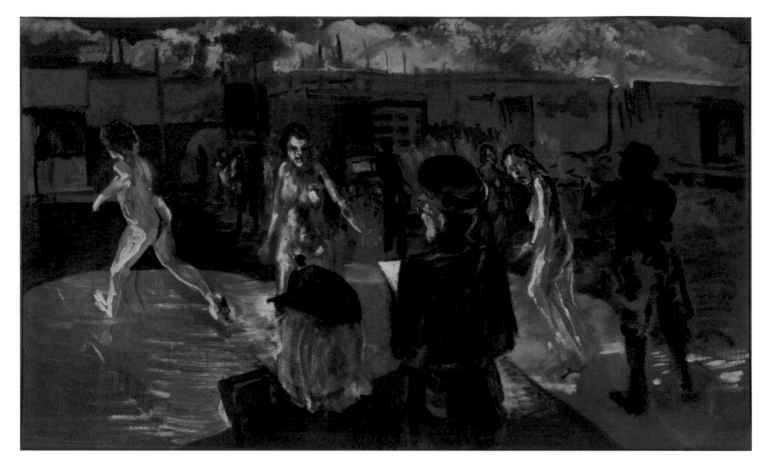

The Selection
41⅞″ x 25″
Oil on canvas
1985

most uncomfortable paintings such as those about war or the mechano-human explorations, he's offering us what he's observed, what he's witness to in the grand terrifying spectacle of human propensity.

The Selection shows an imagined composite version of a concentration camp scene, including armed and uniformed authorities, boxcars, buildings, smoky atmosphere, and of course naked, helpless, humiliated victims. This is a difficult subject and scene to confront, and absolutely iconic of modern times. The subject is not in front of the artist as a portrait sitter or still life might be. The subject presents itself in his consciousness and memory and imagination, deriving from photos, written and oral accounts, and film of these and related events. The drawing in this work comes entirely from Chavez' experience with figures, with buildings, with spaces, with skies. It's fresh; images from the interior have become conscious form on canvas. In this sense much of his work is in the nature of search and discovery, a finding of the image. We see also a particular palette of color, the almost total absence of the kind of saturated color in *Still Life with Goose Eggs*; just a little taste of a reduced orange or yellow- and

blue-green, and the unexplainable implied rectangle of dark red, maybe a subliminal suggestion of the Nazi flag. And we see a sequence of shapes designed to comprise a plane, the space which the figures inhabit. Many of the same pictorial devices visible in *Goose Eggs* are here, but the mix is different, and the subject is distinct. What's similar is the way the work is drawn from external reality and also from the painter's inner life.

■

It's beyond the scope of this book to present an exhaustive account of the artist's life and career. However, even brief discussion of Roberto's work requires mention of his murals, which are not shown in this volume. He's painted half a dozen major murals in the Los Angeles area, some solo and others with assistants. These include a major three-story work in Westwood and, with students, the mural *La Fiesta* at the Los Angeles Housing Authority's Estrada Courts. The most refined and elegant was a mural on the facade of Ingalls Auditorium at East Los Angeles College, *The Path to Knowledge and The False University*. This latter is said to be the largest mural ever produced in East Los Angeles. It was painted out by the ELAC administration in 1979. Tragically, most of the Chavez L.A. murals have been effaced or destroyed. Suffice to say here that Chavez is not only an inspired studio painter, but has the depth of vision and substantial skills to create huge public works – works with meanings powerful enough to seriously challenge authoritarian institutions.

Additional information about the murals can be found in Terezita Romo's review in the *Art Along the Hyphen* catalog. Also, see materials for the comprehensive *Chavez Retrospective* focusing on his East Los Angeles College Mural – a 2014 exhibit to be co-curated by Sybil Venegas and William Moreno at the Vincent Price Art Museum at ELAC.

In concluding the present review, it should be emphasized that no verbal description can do the pictures justice. Explanations, analyses, reminiscences, all can serve to provide an intellectual context for the work. But the work itself is not primarily mental: it is emotional, it is visual, and it is palpably physical. Every effort has been made to reproduce the work as accurately as possible, and the images in this book will communicate powerfully to the attentive viewer. Ultimately, the richness and authenticity of Chavez' work will be most fully appreciated by looking at the pictures themselves.

– Robert Ross, May 2012, Fort Bragg, CA

Why Paint?

Roberto Chavez

Sometimes it seems to me that our society has no use for art or even for knowing what purpose art can serve.

One could make an analogy with food. We need food, not just for something to chew on and enjoy, but to maintain our bodies, that is, as nutriment.

There is a lot of food available to us. Vending machines are everywhere. Every gas station has a food mart where you can pick up snacks for the road as you pay for your gas. In the supermarkets there are aisles and aisles of canned, processed, frozen, bagged, and bottled "food." There are displays of goodies in great varieties of flavors and colors to catch your eye. Lots of stuff to consume. What is missing is nutriment.

And what is that nutriment in art? The potential to journey into the unknown. To quote Joseph Campbell, "a potential for realization and consciousness that are not included in your concept of yourself." The ability to see that life is much deeper and broader than you conceive it.

That can seem like too much work to bother with for people in a hurry. In general, people want to be entertained, not challenged. People do not want to question their sense of who they are, of what it may mean to be fully alive. That is a perplexing thing, something that cannot be grasped clearly, quickly, or logically.

The language of painting is not literary but plastic, not ideas but feeling. By manipulating the paint in terms of shape, texture, value, color, and light, the successful painter can offer viewers a different way of viewing their world.

In our time, the camera provides the main way of observing the world. Even so, cameras come as close to recording experience as Xs on a page feel like real kisses. Part of the problem is that our machines have become replacements for our own experience of life. Cameras copy nature, badly. Art seeks not to copy nature but rather to emulate it, to be in unison with nature.

That requires an attentive awareness that our machines seem to make unnecessary. We need artists to show us, in a deeper way, how things are and how they could be. This all makes for an interesting time (in the Chinese sense) for artists.

We have exhibits and competitions. Many artifacts are sold by the big auction houses as investments, while others are peddled as home décor at the local arts and crafts fair. Such transactions belong to the world of trade, simply another arena of competitive or commercial dealings.

Art, as I understand it and have tried to practice it, lies in another realm altogether: the spiritual, that is, relating to the human spirit (or soul), as opposed to the material or physical. Art is not concerned with material values or pursuits.

My first "artistic" experience came at a very early age, possibly before I had mastered language. I was sitting on a rug, looking at the pattern in front of me. I saw that it consisted of shapes of different colors. I found that by shifting and modifying my focus I could change the relationships of the colors and patterns. It was rather like staring first at the red, then at the black squares on a checkerboard, but this rug pattern had more colors, a greater variety of shapes and textures.

My consciousness included the feel of the rug on my bare legs, the sounds from another room, a terrific sense of well-being, and the fact that my whole visual field was a part of these sensations. The distinction between me, as the perceiver, and that which I was perceiving disappeared. I became one with that which I was looking at. I felt expanded and totally content. I believe that we all have the capacity for such insights. Possibly everybody has had at least one such episode. There are undoubtedly differences in the intensity and length of them, but I believe they are part of the human potential.

But of course the difference between this type of experience and the accepted or conventional way of seeing things can make it hard, even dangerous to share such an experience with others. Ridicule, ostracism, or worse can result. The fear of this reaction may cause one to suppress and forget the event and to avoid the chance of a reoccurrence.

It is my opinion that humans need to cultivate this facet of existence for their own inner harmony and for the good of the species and of the earth as our home.

The arts often explore this realm and can be helpful in bringing us into harmony with nature and with each other, fully integrated with life. What is involved is a confrontation with the mystery of life. We are not comfortable with mystery, something that we have not the words to understand. But logic is not our only resource for this journey.

We have other ways of understanding: our organs of sight, hearing, smell, taste, and touch, which operate independently of thought. Art helps us feel comfortable with experiences that give us a sense of what an incredible thing it is to be alive as humans in this awesome and beautiful place.

I paint to achieve this. In working with my materials I challenge myself to let go of expectations, to trust that the medium, and my body, will guide me in learning to trust the unknown.

You could say that I paint to discover what painting is.

Originally published in *Aztlán: A Journal of Chicano Studies*

Some Remarks About My Work

Roberto Chavez

Good Afternoon, I am very happy to be here. First, I would like to thank the Autry museum for including me in this important cultural event. It is an honor to be here.

I have come to talk about my work that is included in this exhibit. The title of the show, *Art Along The Hyphen: The Mexican-American Generation,* represents to me a blending of cultures of which I am definitely a product. I see the exhibit as a bridge between peoples, utilizing the visual arts.

I think that there is a positive, creative energy and excitement that occurs when different peoples come together. This can create a new entity. A third culture that is constantly renewed as it evolves with the parent cultures. The work on display here is a result of this kind of coming together. I would like to take a little time to tell you about what this means to me.

My parents came to Los Angeles from Mexico in 1920. I was born in East Los Angeles in 1932. I was the ninth of twelve children. This was in the middle of the Great Depression. And, although it was at a time of extreme economic hardship in this country, my parents and their friends were happy to be here. They had escaped the dangers and chaos in Mexico and could now live in safety. There was also the possibility of improving their lives and those of their children.

Keep in mind that this was, in many ways, a very, very different Los Angeles from what it is today. This was a time before television, freeways and smog; before Xerox and fax machines; before computers and cell phones. At that time the population of the city was just over a million.

The community where I grew up was a mixed working-class neighborhood that was predominantly Mexican in the immediate area. We called it *Maravilla*, which in Spanish means a marvel or a wonder. And it was that indeed.

The local shops were owned by Mexicans, and business was conducted in Spanish for the most part. Some of the products sold were of

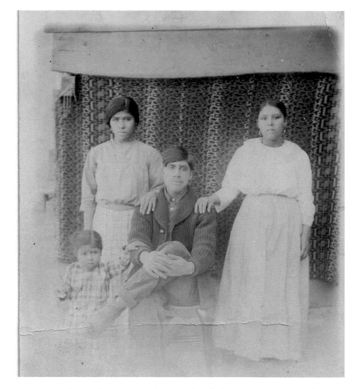

Right to Left: the artist's mother Ester Chavez, his father José Chavez, his father's sister and her son, just before his father came to Los Angeles; Chihuahua, Mexico; 1919; Photographer unknown

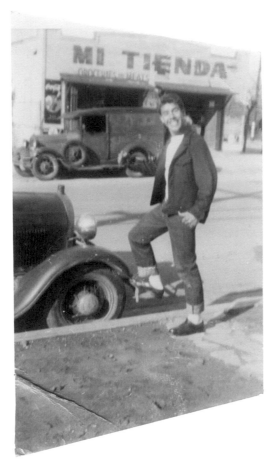

Chavez standing at his next door neighbor's car, with the neighborhood grocery across the street; Corner of Michigan and Marianna Avenues in the *Maravilla* neighborhood of Los Angeles; Circa 1948; Photo: Victoria Alaniz

Mexican origin. We loved going to the *panaderia* with its heavenly smell of *pan dulce* that sparkled with sugar toppings of many colors. The *tortilleria* had its distinct aroma of toasted corn and the sound of the women chatting as they made the tortillas by hand. When we paid for our purchase, the owner would hand us a fresh rolled tortilla, hot off the griddle, to eat as we walked home, the warm package of tortillas cradled in our arms.

We walked everywhere, to the shops, to the movies, and to school. We, the children who were in school, were exposed to a world that was considerably different from that of our parents and their friends. The people portrayed in our classroom English readers or in the movies we saw did not resemble the people that we dealt with in the neighborhood or at home. There was so much to learn. So much to see.

In the same kitchen where my mother cooked pigs' heads for *tamales*, my sister baked a lemon meringue pie. She made Jell-O and other American dishes that she learned about in school. One Sunday we might have *menudo* for breakfast and the following week pancakes with Karo syrup.

In one theater we watched Mexican movies with actors like Cantinflas and El Chato Ortin, while in another we saw American films starring James Cagney and John Wayne. After the movies, we could buy a hot dog or a *raspada* sweetened with red, green, and yellow syrup.

We heard popular Mexican songs and Big Band music on the same radio. In church we saw the luminous, brightly colored, life-size statues of saints, and in the street young men in their shiny sharkskin Zoot suits. We learned American history in school and heard about Mexican history from the adults at home.

Spanish was our first language but we children used English as readily as Spanish. We often mixed the two, creating words and phrases that neither our parents nor our teachers understood. In our house we read Spanish language newspapers and Mexican magazines, along with the Sunday Examiner. I devoured school books and other books that my father brought home from the salvage shops that he did business with. I remember books on geography, history, medicine; an unabridged English dictionary and, best of all, for me, a thick book of pictures with hundreds of engravings of cowboys, Indians, cattle stampedes, and all the romance of the American West.

Besides language there were many other contrasts of culture that were a part of my growing up. The three Catholic churches and the sound of their bells were a background to the hymns we heard being sung in the Baptist church across the street. At school we brought *burritos* for lunch unlike the sandwiches some of the other kids had. We heard a variety of programs and music on the radio: such as the Mexican comic Agapito one night and *The Shadow Knows* on another night. Records of Harry James and Pedro Infante were played on the same record player.

The barrio was a vibrant mix of color and sounds. There were flower gardens with pink, red, and white blossoms, and chickens clucking in

the back yard. In the homes one could see red, green, and white *sarapes* draped over the living room couch, iridescent saints calendars on the wall, and terracotta water jugs adorned with blue, brown, and white geometric bands on the kitchen counters.

On certain days we heard the sound of street vendors hawking their goods door-to-door. Shouting out "*Naranjas, tamales, cabezas.*" The clanking iron wheels of the weathered horse-drawn cart alerted us that the *garrero*, the rag man was here to collect metal, rags, newspapers, and other recyclables in exchange for pennies.

Yes, *Maravilla* was indeed a marvel; a diverse and rich environment. I know that others have written about and described the barrio as well and in more depth. However, I wanted to share with you today some of the impressions of my youth that are the source and inspiration of my art.

In college I learned to paint based on European models, but these elements from my culture of origin are recurring influences that emerge in the pictures I conceive, as are the feelings associated with them.

I became interested in drawing at the age of four when I watched my father writing a letter. I saw that he was decorating it with drawings on the margin of the page. He was creating funny faces with pencil lines like the ones in the magazine cartoons. I got a pencil and tried to do the same, and with my first success I was hooked. Permanently.

From that time on I was always drawing. I studied the illustrations in the papers and magazines to see how they were done. I saw pictures differently now: as constructions of lines, dots, textures, and shapes. I have to say that I was very lucky that my family and teachers encouraged me in this, and praised my efforts.

At home, using machine parts that were a part of my father's metal recycling business, I made toys that were my first ventures into sculpture. This made me very aware of form and structure. They are the essential building blocks that I have used for effective pictorial composition.

While I was in high school, two incidents occurred that helped guide me in the direction that I took. I had an art teacher who liked my work and suggested that I take art as a major in college. At the time I had planned to go to college but I had not known that art was an option. The idea was very exciting to me.

Secondly, I saw an exhibit of modern art that really opened my eyes as never before. In that exhibit I saw several paintings of flowers by the French painter Renoir that helped me see the potential of paint. They seemed to be not pictures of flowers, but rather paint that was alive on the surface of the canvas that created patterns, patterns that conveyed the forms of flowers to the eye. It was a totally new visual experience for me. It was as if they were animated in a way that I may have imagined, but had not ever seen. I found myself looking at things in a new way. Seeing them as brushstrokes and color shapes, painting and drawing them in my mind. I knew then what I wanted to do. I wanted to make paintings that had that kind of magical energy.

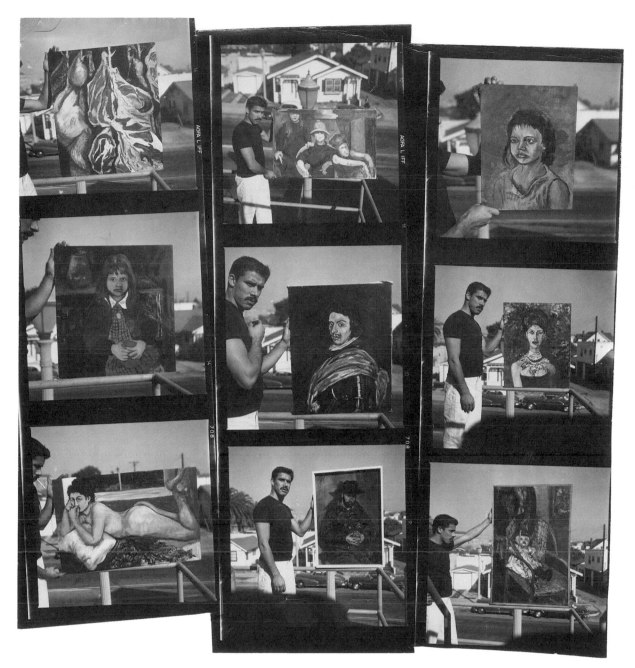

The artist with some of his paintings on the porch of his studio; Main Street, Venice, CA; 1958; Photos: Hal Glicksman

After graduating from high school, I enrolled at Los Angeles City College as an art major. From there I transferred to UCLA and obtained both a Bachelor's and a Master's degree in Pictorial Arts. As a graduate student I began teaching lower division art classes. After that I taught in the UCLA extension program and part-time in the Community College District. In 1969 I was hired full time at East Los Angeles College and with another instructor initiated the Mexican-American Studies Program. I taught classes in Art and Chicano Studies there until 1981 when I resigned my post and moved to Northern California for ten years.

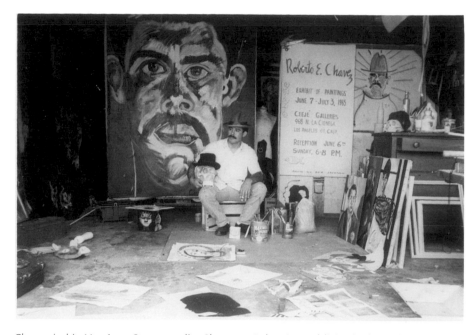

Chavez in his Morrison Street studio, Sherman Oaks, CA; Publicity for his solo show at the historic Ceeje Galleries in Los Angeles; 1965; Photo: Ben Jackson

I have continued painting and teaching. I worked in many places with many different populations, the last being sixteen years teaching art to inmates, both men and women, in California State Prisons. I retired from teaching in 2008.

My first solo exhibit was my Master's Thesis in 1961. This gave me greater confidence that my way of working could be appreciated. Less than one year after graduating from UCLA I began to exhibit at the newly opened Ceeje Galleries on La Cienega Boulevard, in Los Angeles. I mounted the first one-person show in that space. I continued to exhibit there for many years. Since then I have exhibited in many venues and places. And now here, at the Autry.

Now I would like to say a few words pertaining to the work that I have in this show. All the work of mine that you will see here was done over forty-five years ago. The oldest, entitled *John Bananas*, was fifty-three years old this past summer. The paintings were all done when my old neighborhood was very much the way that I have described it. But it no longer exists.

Neither does the person that painted those pictures. Many things have changed in the world since then and I have changed as well. I am still painting but my painting has evolved, although, for me, the excitement I felt when I was drawing as a child remains alive in my work. The remembrances of the neighborhood of my youth are as much a part of me as is my Mexican accent. They influence my work when they will and however they will, I really don't have to think about it – as in the background in the painting of *Tamalito del Hoyo* (page 24), which reminds me of the feel

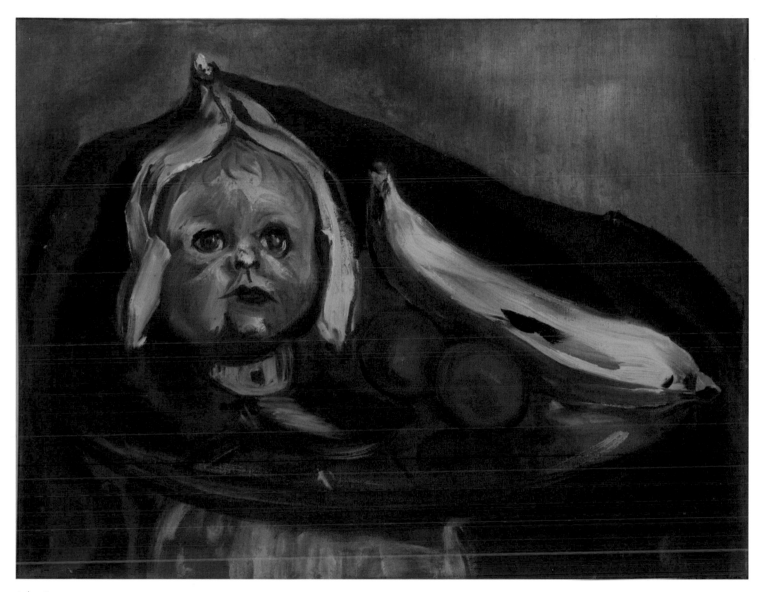

John Bananas
20″ x 15 ⅛″
Oil on Canvas
1959

of that time and place. The old frame house, the worn, dusty cement, and the graffiti, simple and unadorned as Tamalito himself, in his tired Khaki pants and war-surplus combat boots.

All of the portraits in the show were done from life with two exceptions: *Emiliano Zapata* (page 34) and *The Group Shoe* (page 35). The portrait of Emiliano Zapata is one of five studies that I did from a photograph of the Mexican Revolutionary leader. The work was inspired by what I knew of the period of revolution from reading I had done, and from listening to the accounts of my father, my mother, my grandmother and my father's brother. They were, all of them, refugees from the horrors of war in their home state of Zacatecas.

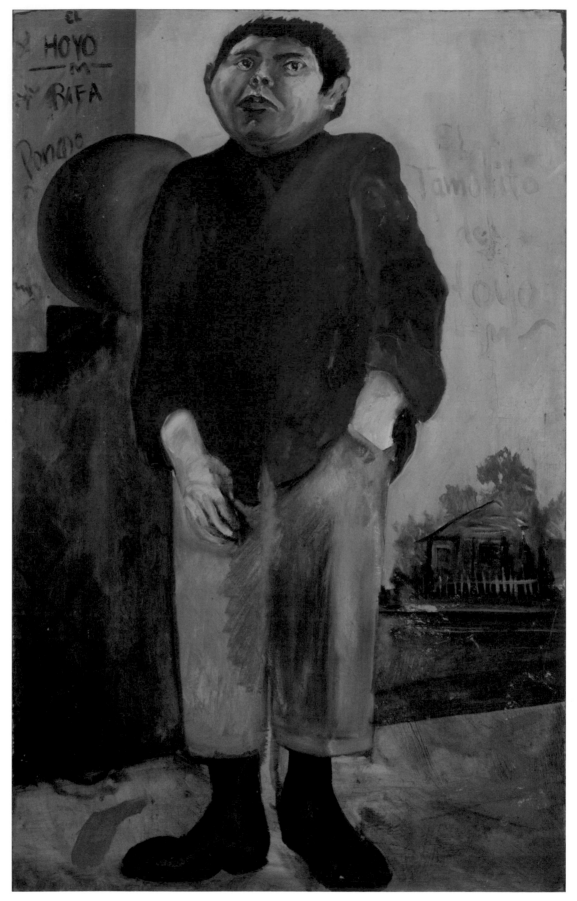

Tamalito del Hoyo

25" x 40"

Oil on panel

1959

Collection Smithsonian American Art Museum

I tried to portray in *Zapata* the dilemma and disillusion of the idealistic warrior, a look I believe that I saw at times in my father's eyes. I have never liked working from photographs, but in this case and in *The Group Shoe* my pictorial intent got the better of me. In *The Group Shoe* I was celebrating the excitement, and inserting a note of insouciance into the whole affair. The idea of me and my painting buddies having our first professional show. Having our debut as it were.

I have painted many still lifes and self portraits for practice, much as a musician might play scales on an instrument, to refine my compositional and painterly skill in working with different surfaces and spatial elements. But, rather than arranging the usual or exotic subjects often depicted, I have preferred to select familiar objects that I find around the house – things like fruit from my garden, a milk bottle, a clay dish, and a doll that my daughters had abandoned. Much more challenging, and for me, more meaningful.

But really, the most important thing that I wanted to say was a bit of how I perceive painting and what it is good for. I strongly believe that painting is best experienced when it is approached without preconceptions, before words and concepts get in the way.

I am referring to that moment when we see something, but before we attach a label to the experience. This moment of mystery is an opportunity to perceive reality in a fresh, unexpected way; to be aware of seeing outside of our usual point of view, the way you might look upon a flower or a bird that you had never seen before. To be able to do this, as one teacher told me, we have to bypass our brain and connect our eyes to our hearts. To see in the way that we saw before we learned the names for things. To feel, more than to analyze. One can then experience the visual world for the marvelous place that it is – a place that inspires feelings of wonder and delight, and of connection.

As an artist I have tried to give form to that way of seeing the world. I work in the spirit of the painters that have inspired me.

I hope you enjoy the show. Thank you.

Address by Roberto Chavez prior to opening the Autry Museum Exhibit
Art Along the Hyphen: The Mexican-American Generation, October, 2011

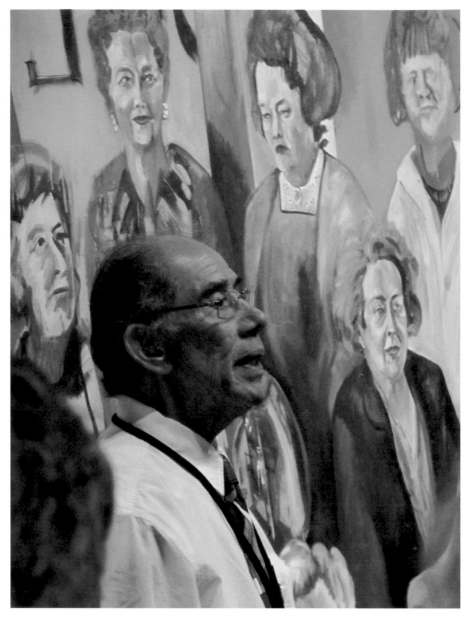

Roberto Chavez at his Autry Museum Opening, 13 October, 2011; The artist in front of his painting *Ladies' Art Class*, now in the collection of the Autry; Photo: Mary Scott

Reproductions

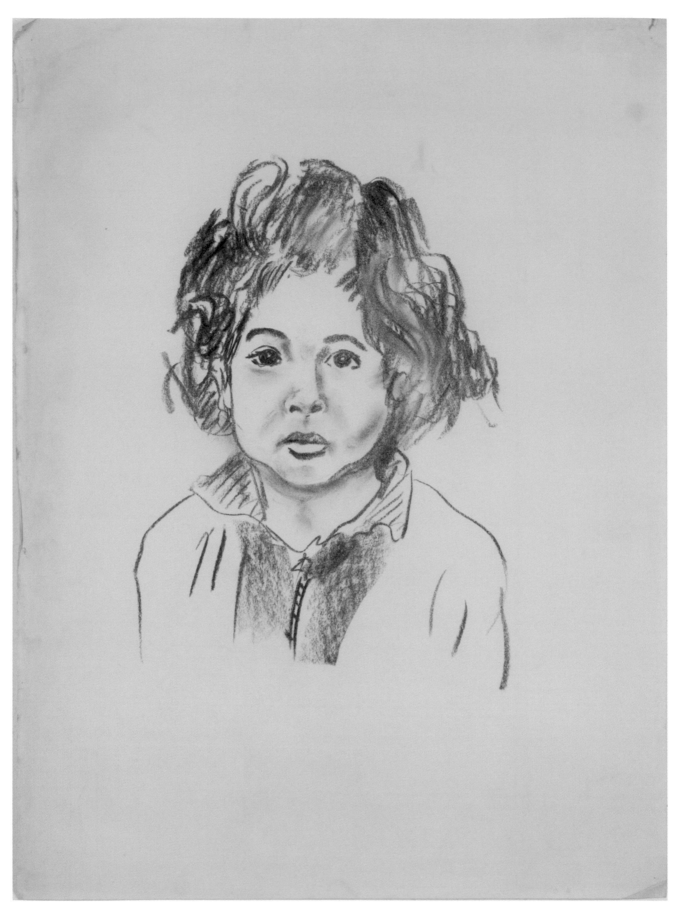

Sojilocks
18″ x 24″
Charcoal
1967

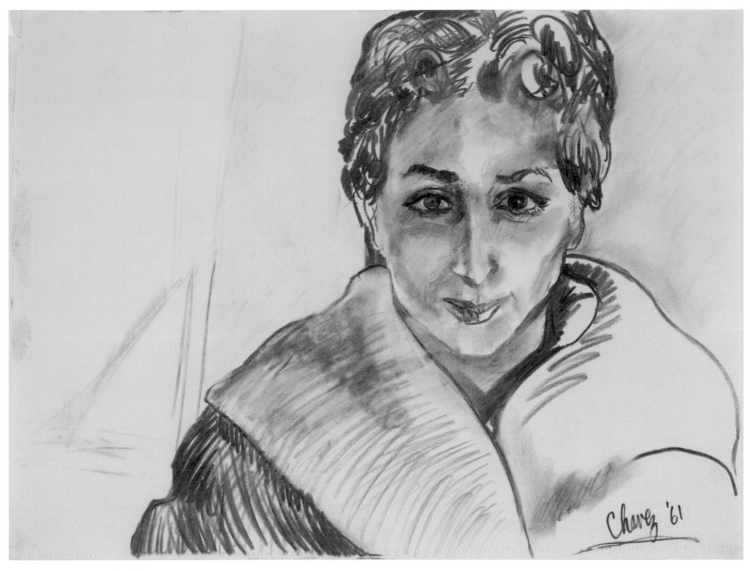

Young Woman in Bathrobe

24" x 18"

Conte crayon

1961

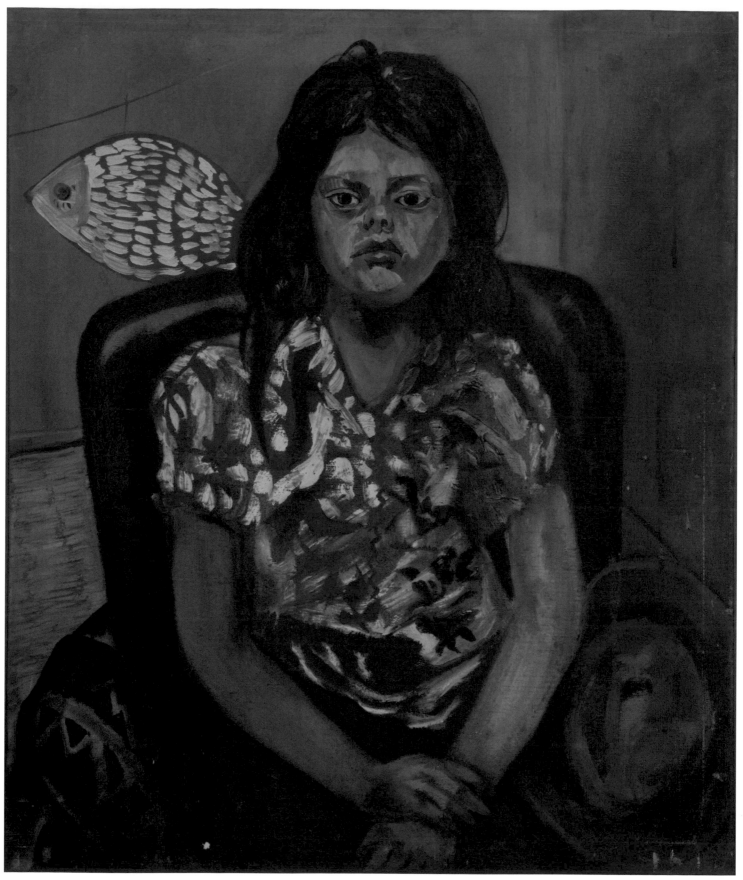

Vivian with Fish
25¼″ x 29¹⁵/₁₆″
Oil on canvas
1968

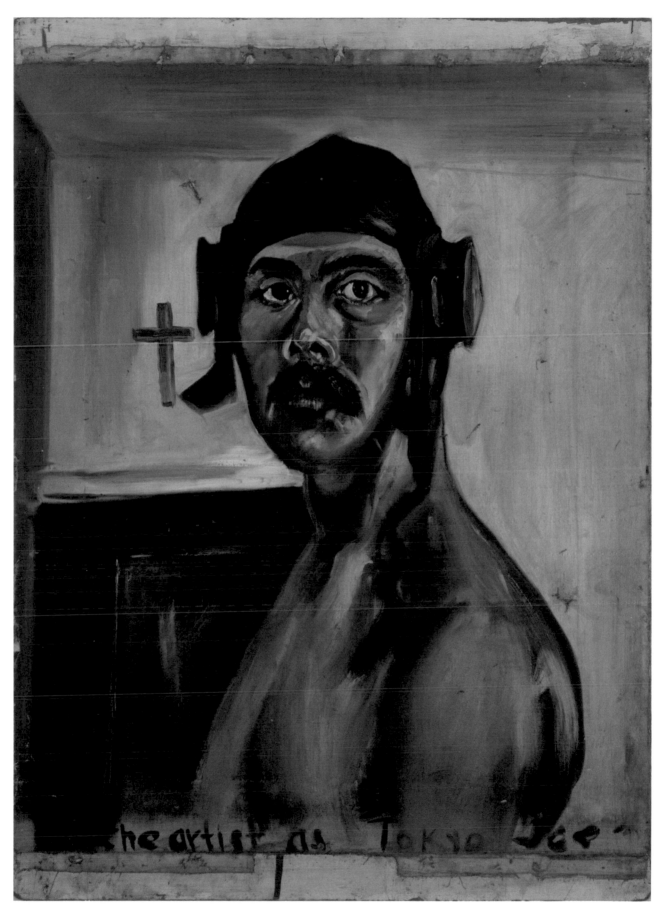

The Artist as Tokyo Joe
24⅛" x 33⅛"
Oil on canvas mounted on panel
1959

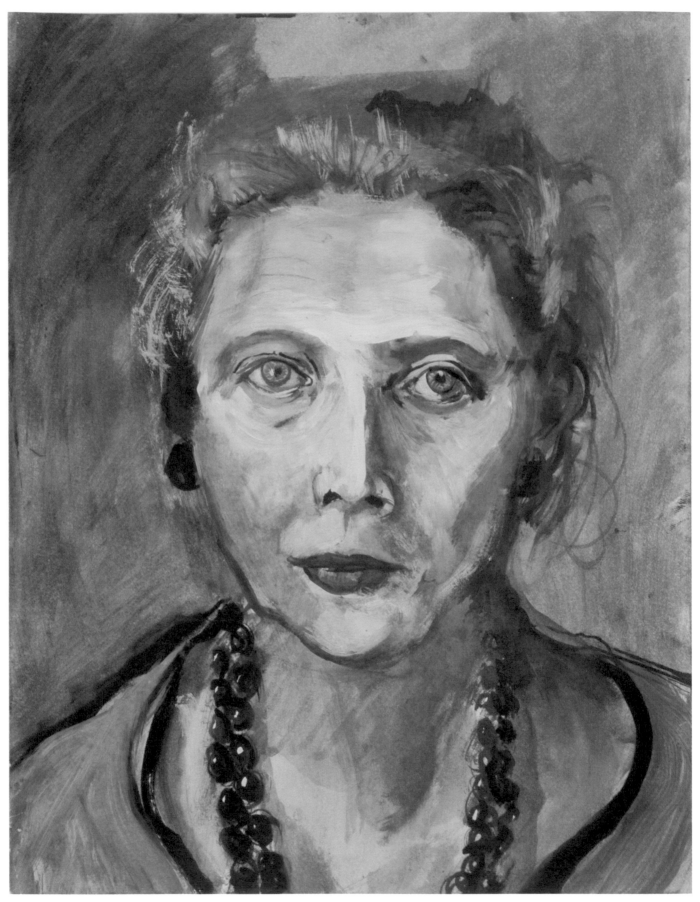

Portrait of Helen Hayevski
8½″ x 11″
Oil on paper
1951

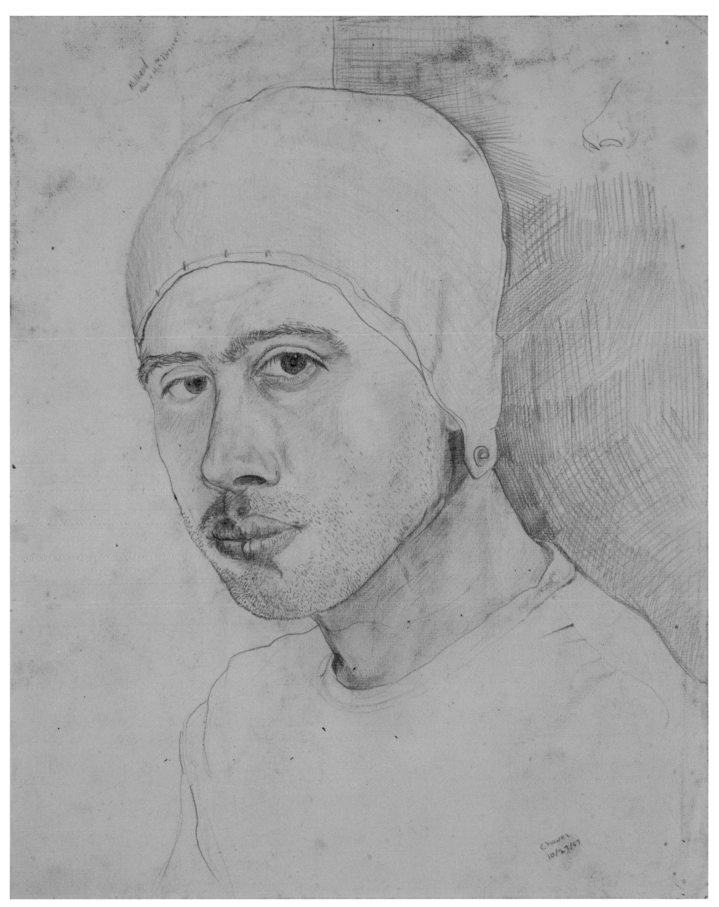

Self Portrait with Swimming Cap
14⅞" x 19"
Pencil
1957

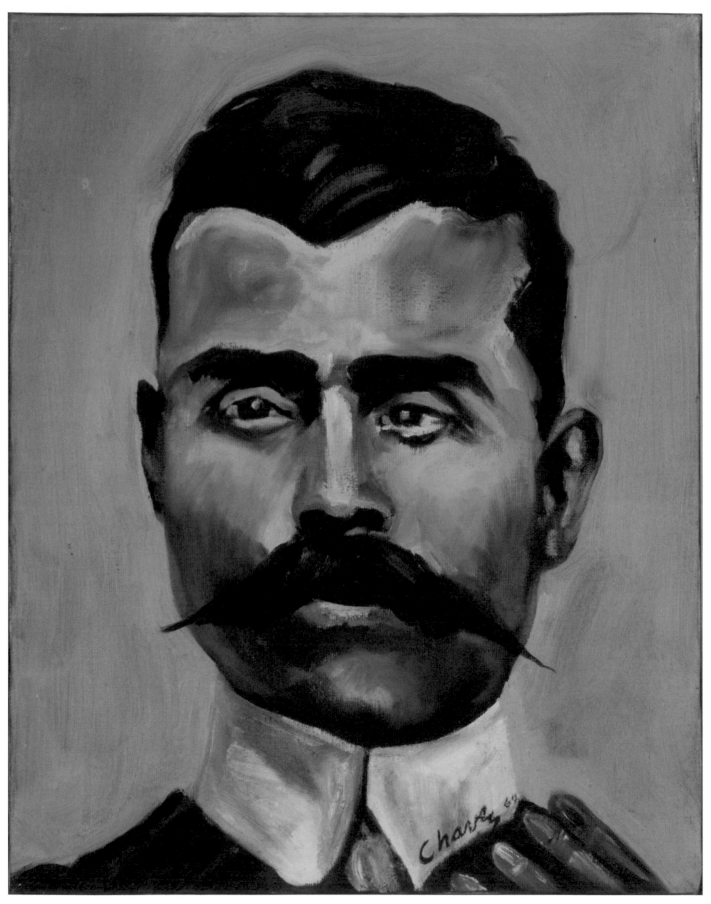

Emiliano Zapata
14″ x 18″
Oil on canvas
1963

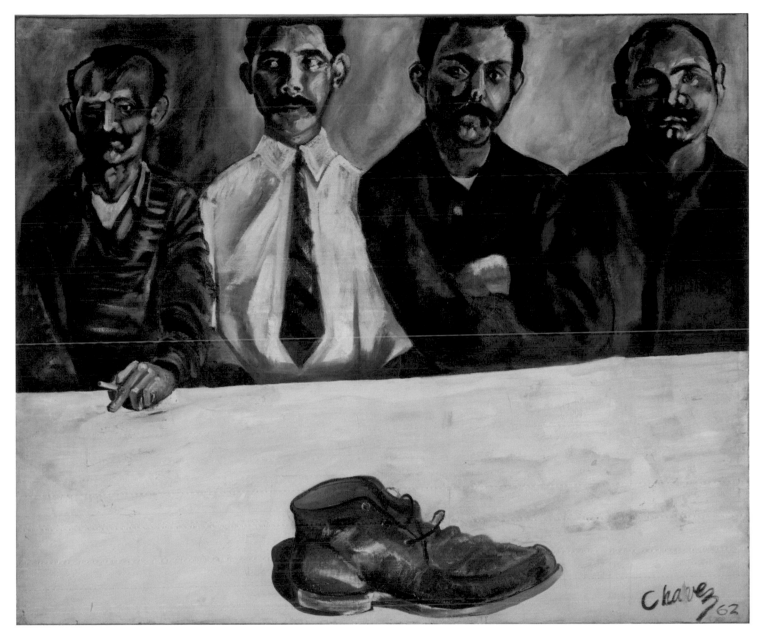

The Group Shoe
60" x 50"
Oil on canvas
1962

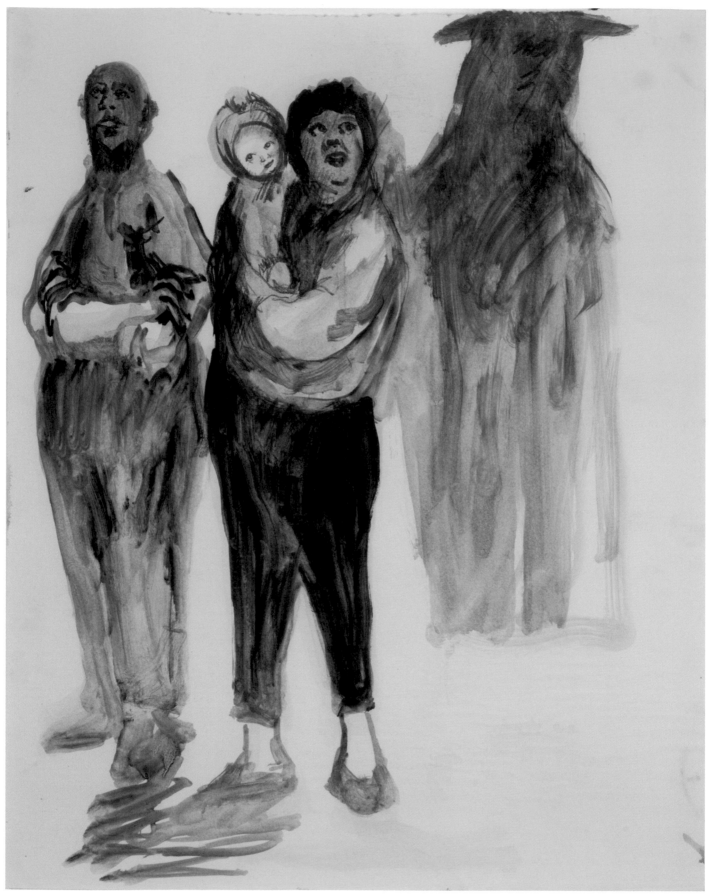

Spectators at Execution
19" x 24"
Oil on paper
1961

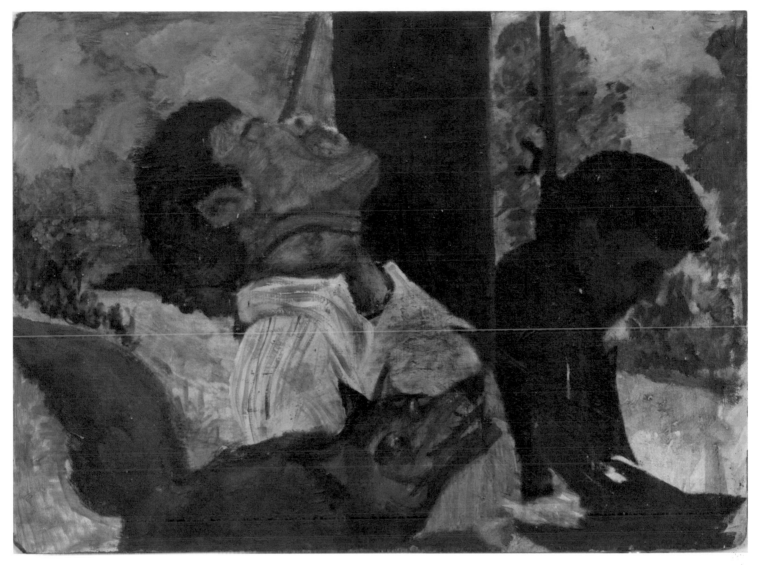

Executed Men
29″ x 19½″
Oil on panel
1958

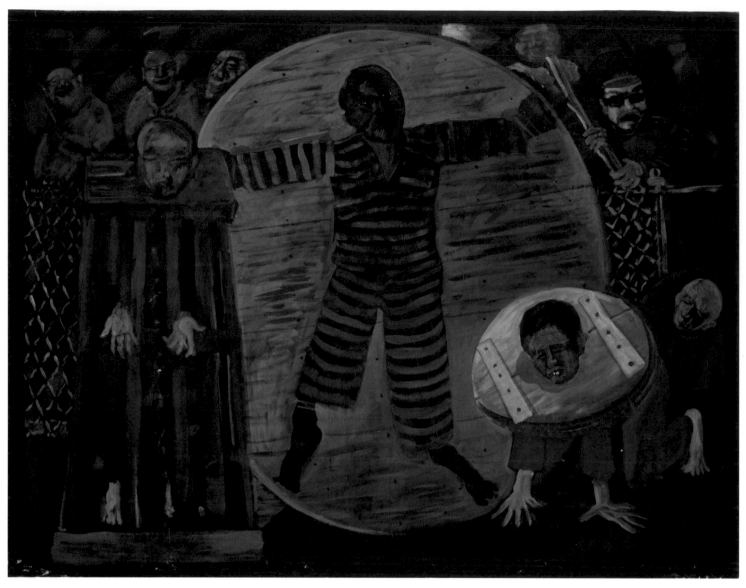

Condemned Man
71¾″ x 54½″
Oil on canvas
1993

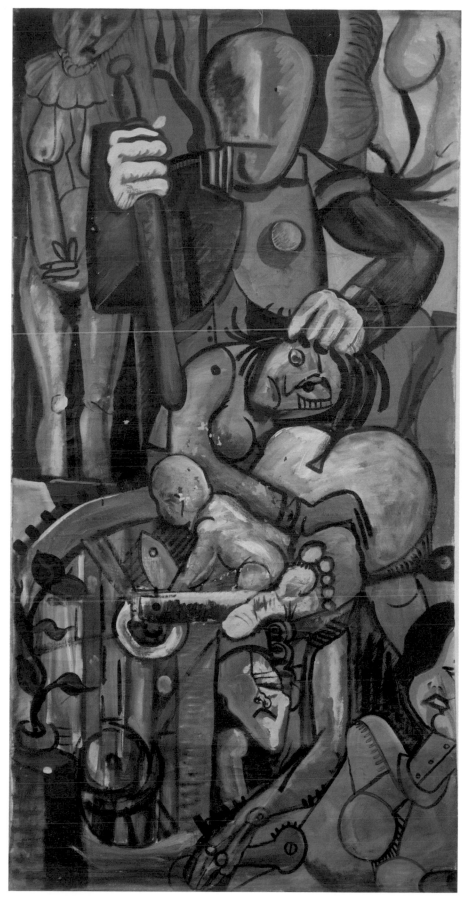

Chorizo Factory
35¾" x 70"
Oil on canvas
1970

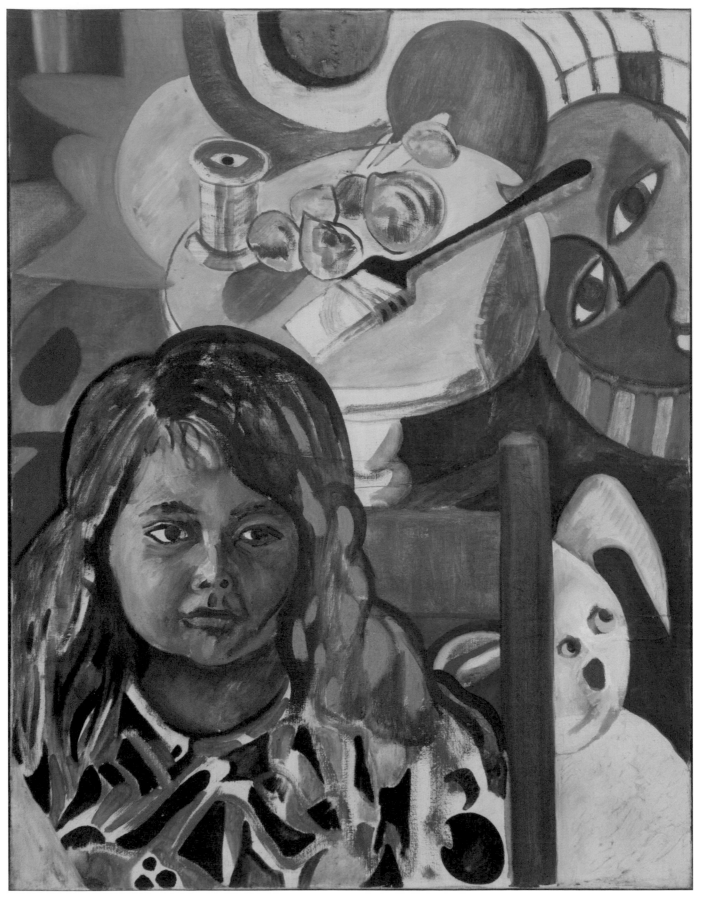

Marina
22″ x 28″
Oil on canvas
1969

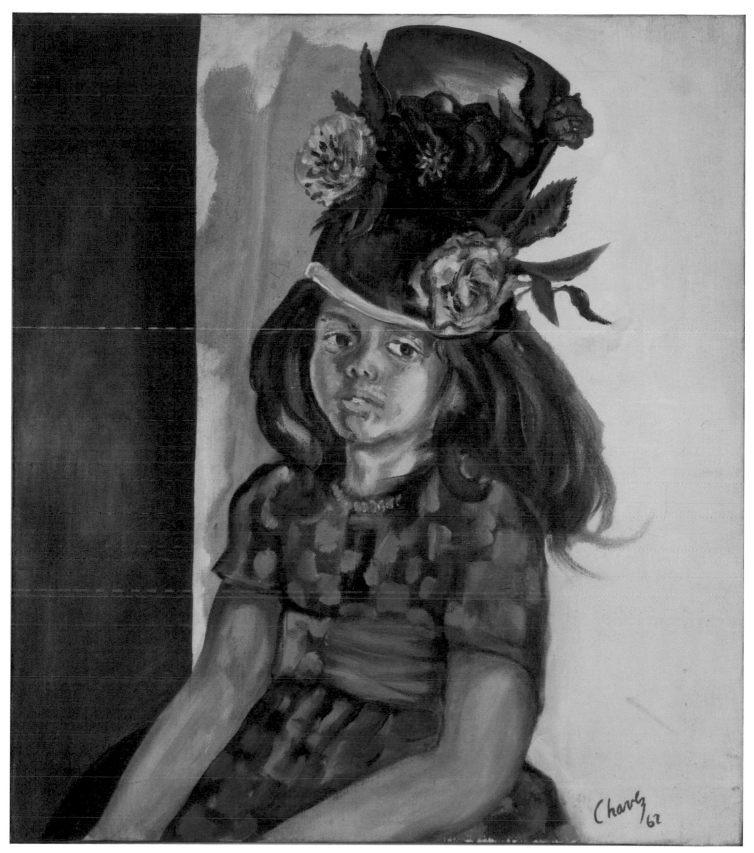

Vivian with Flowered Hat

21" x 24"

Oil on canvas

1962

Private Collection

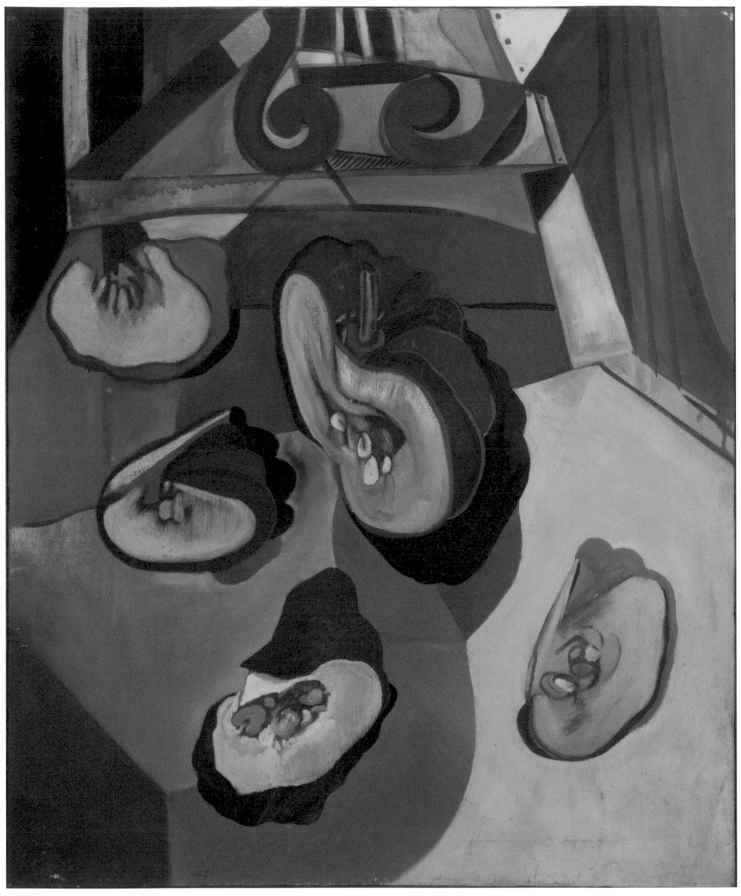

Squash
25¼″ x 30⅝″
Oil on canvas
1968

42

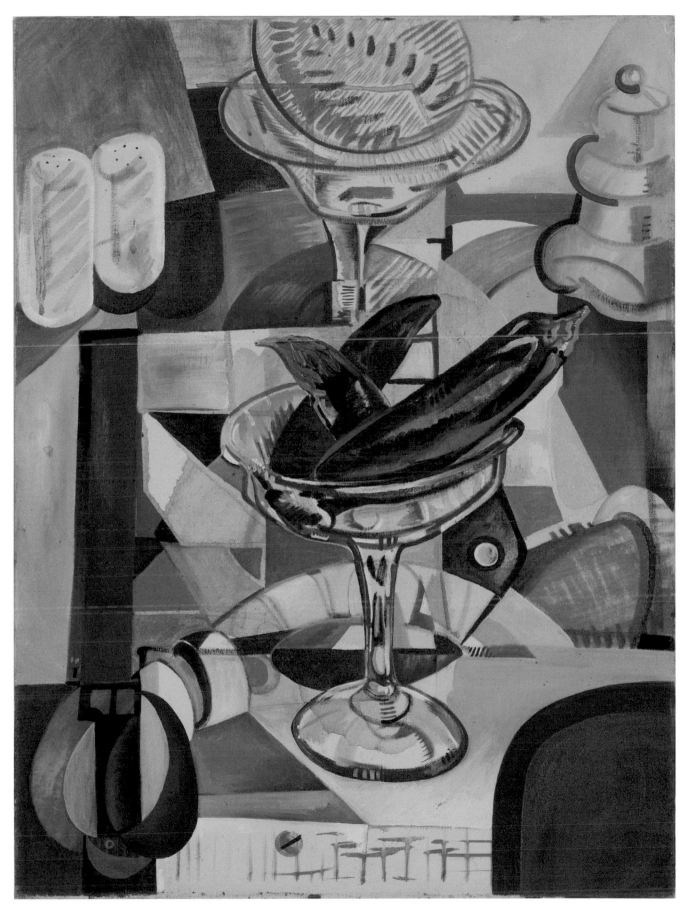

Still Life with Japanese Eggplants

17⅞" x 23⅞"

Oil on canvas

1979

Private Collection

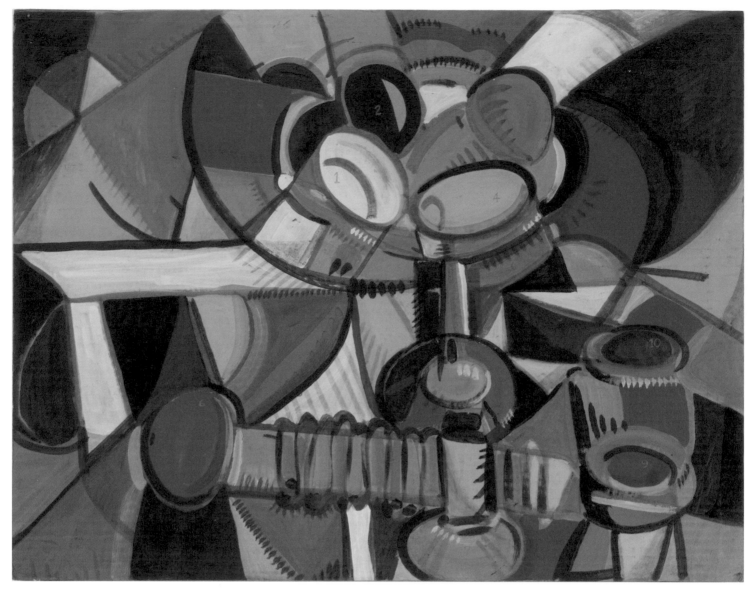

Compote with Fruit
21½″ x 16″
Acrylic on cardboard
1970

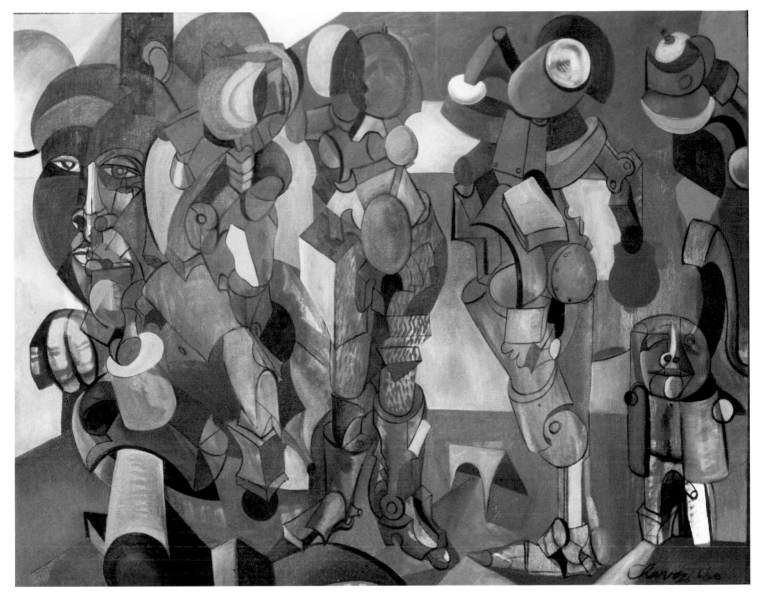

Sketch for a Masterpiece
48″ x 36″
Oil on canvas
1963

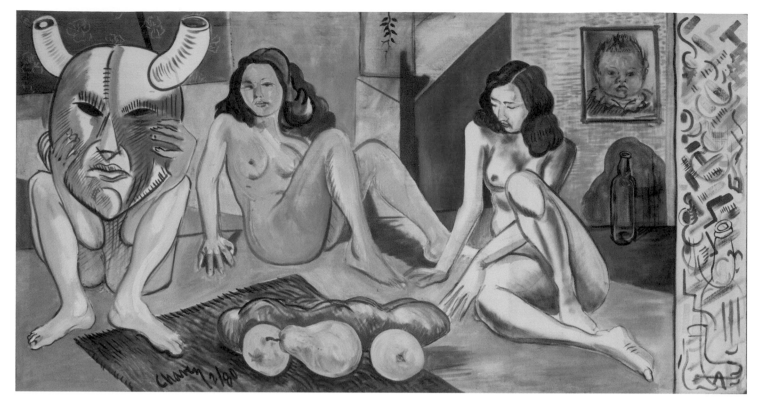

Asian Models
72¾" x 38"
Oil on canvas
1980

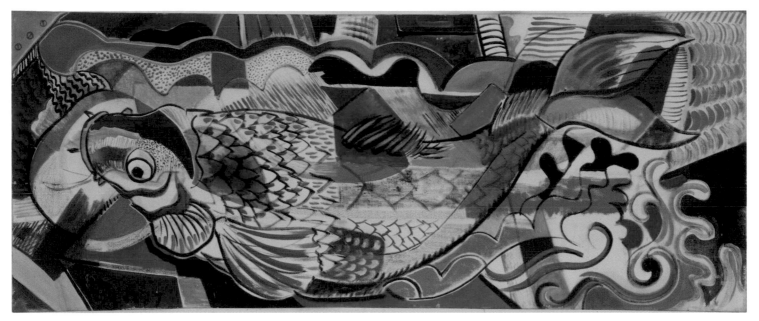

Carp
48⅛″ x 19⅜″
Oil on canvas
1981

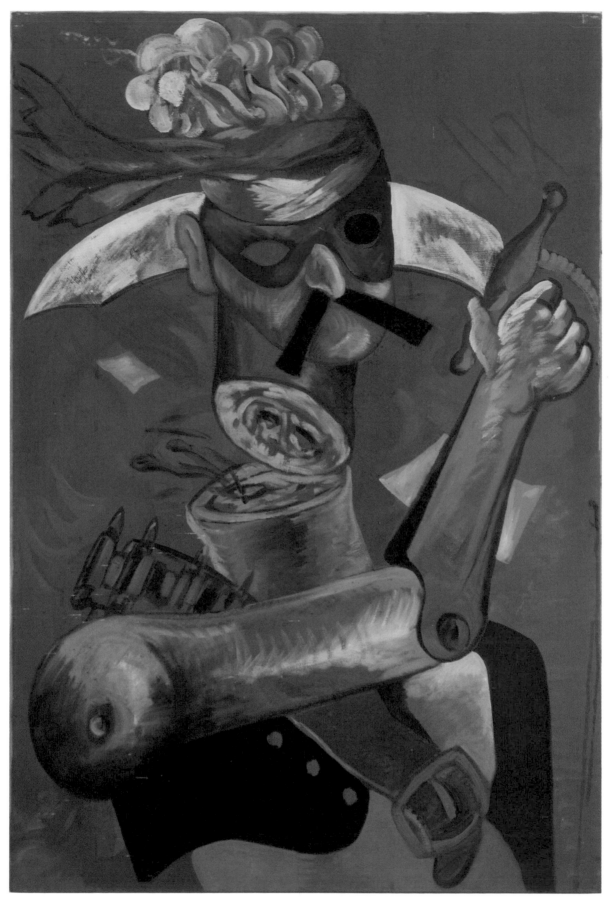

Kill the Ego
24″ x 36″
Oil on canvas
1984

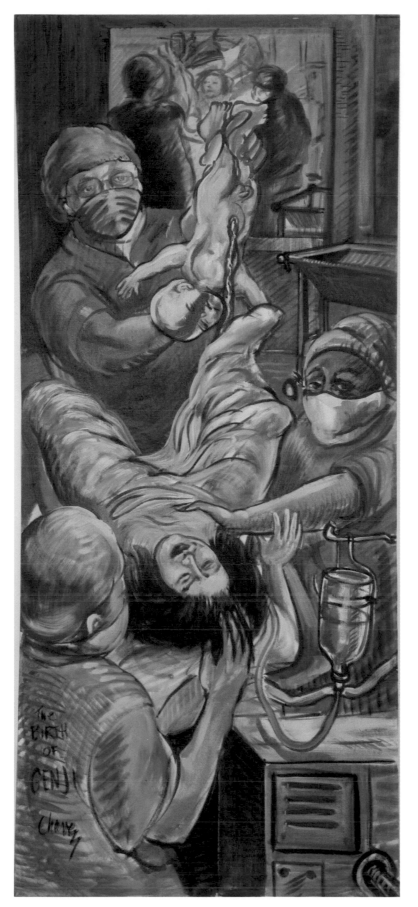

Birth of Genji
27¾" x 65¼"
Oil on canvas
1980

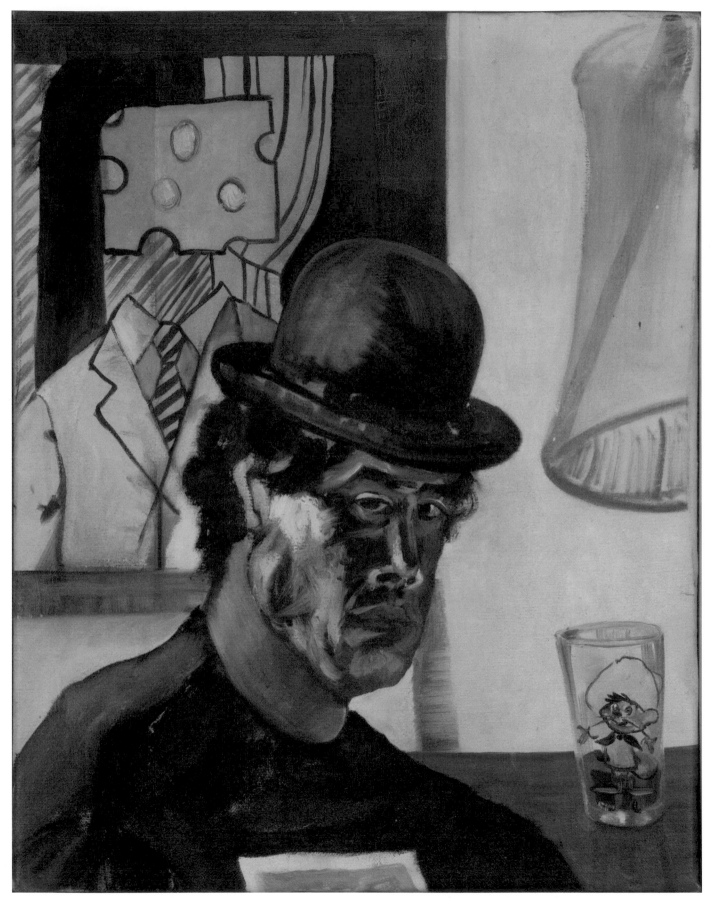

Self Portrait with Speedy Gonzales

15½ x 19½

Oil on canvas

1963

Collection Smithsonian American Art Museum

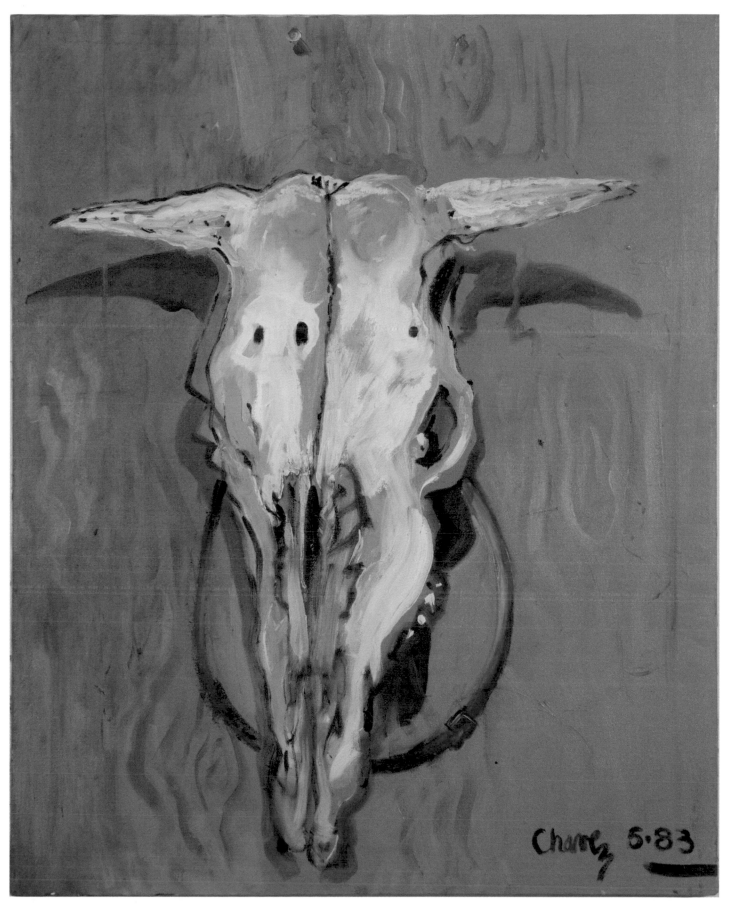

Cow Skull
24" x 30"
Oil on canvas
1983

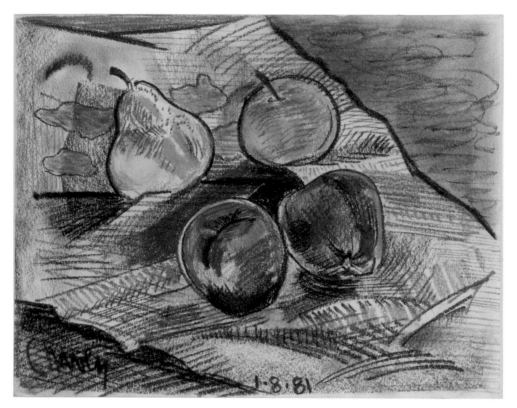

Fruit on Paper
13¾" x 10¾"
Oil pastel
1981

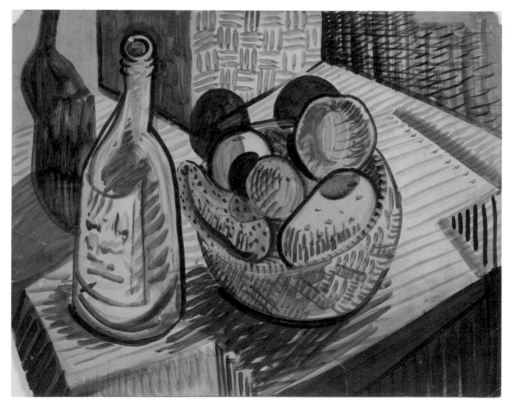

Still Life with Wine Bottle
28" x 22"
Acrylic on cardboard
1970

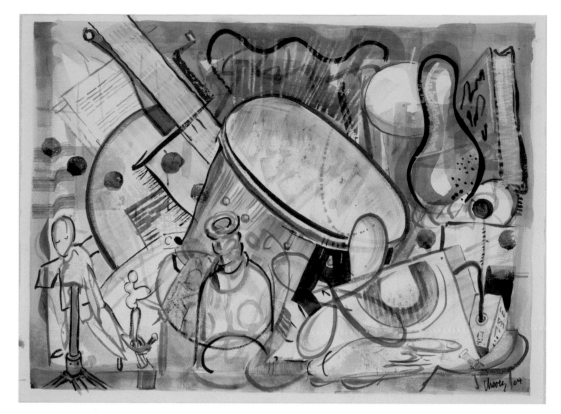

Still Life with Drum
Sumi ink on paper
21" x 28½"
2004

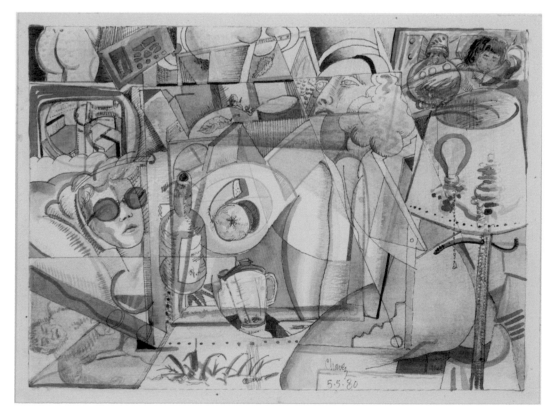

Vitamix
11⁵⁄₁₆" x 8⁵⁄₁₆"
Pen and ink, watercolor
1980

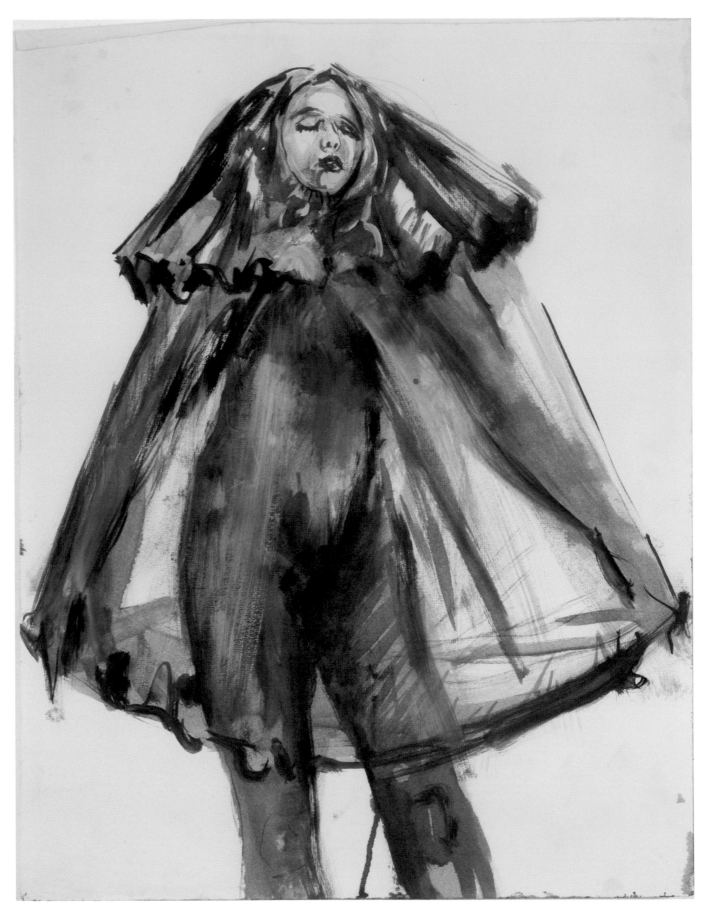

Draped Nude
19" x 25"
Oil on paper
1961

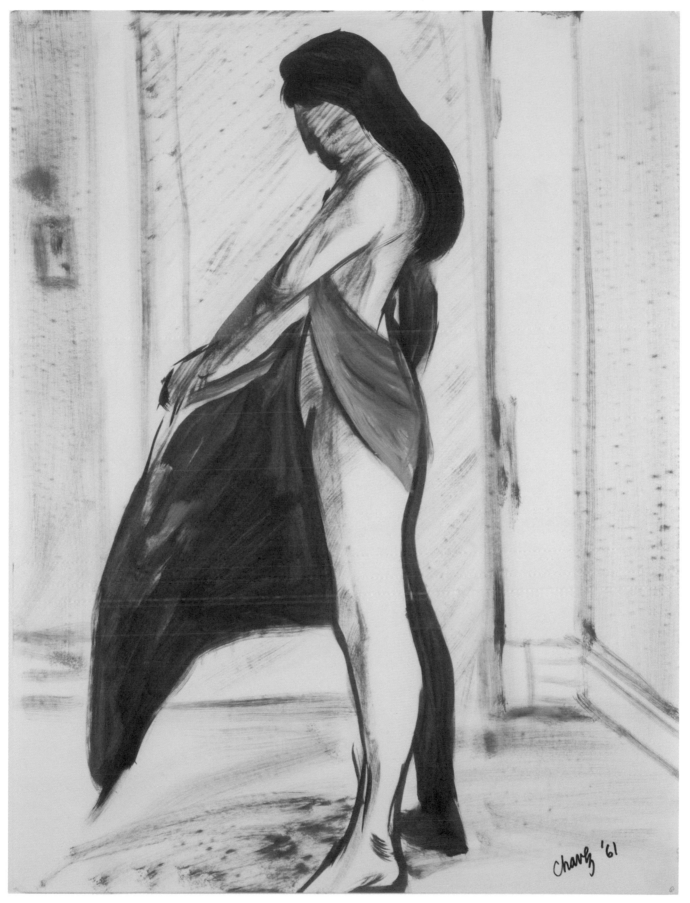

Nude Draping Herself

18" x 24"

Oil on paper

1961

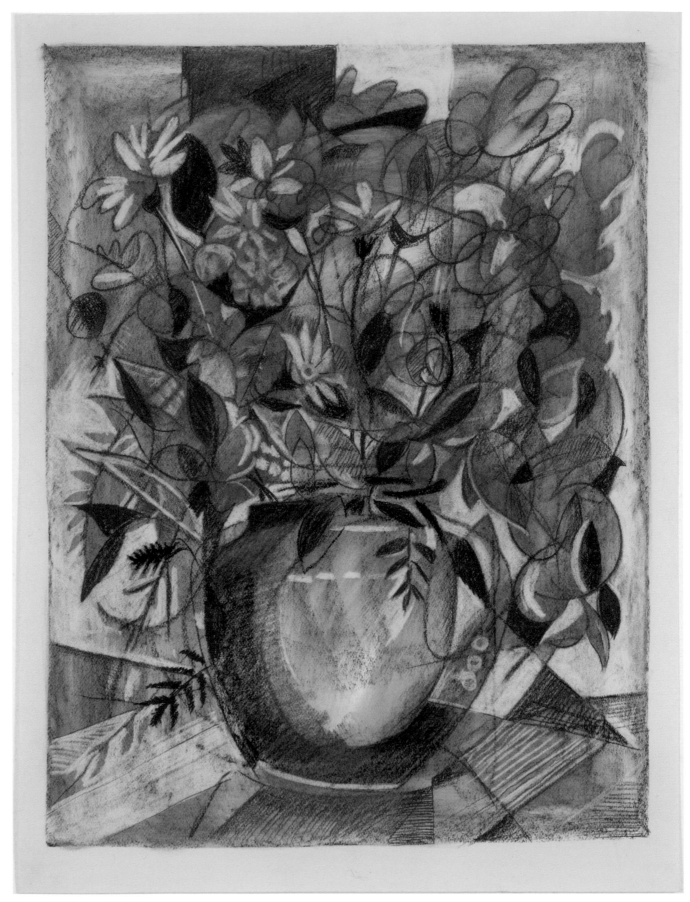

Bouquet
18″ x 24″
Charcoal, chalk
1993

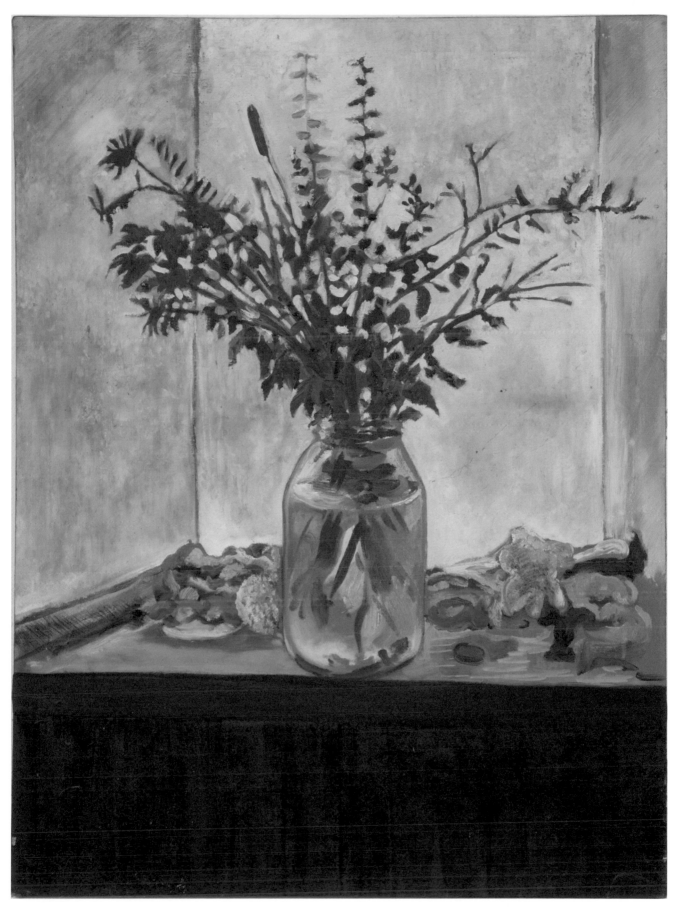

Jar Vase
29⁷⁄₈″ x 48″
Oil on canvas
1985

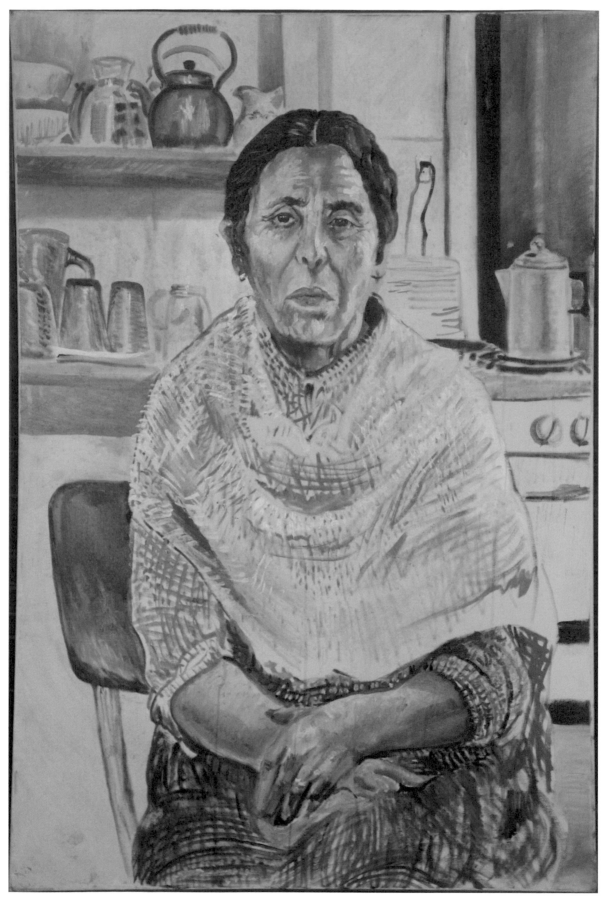

The Artist's Mother
24³⁄₄" x 36¹⁄₂"
Oil on canvas
1972
Private Collection

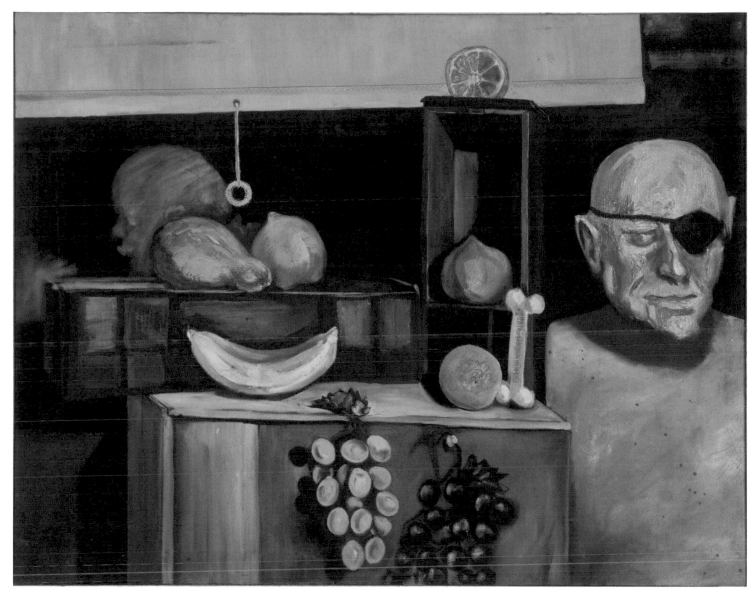

Still Life with Alabaster Banana
42″ x 33″
Oil on canvas
1960

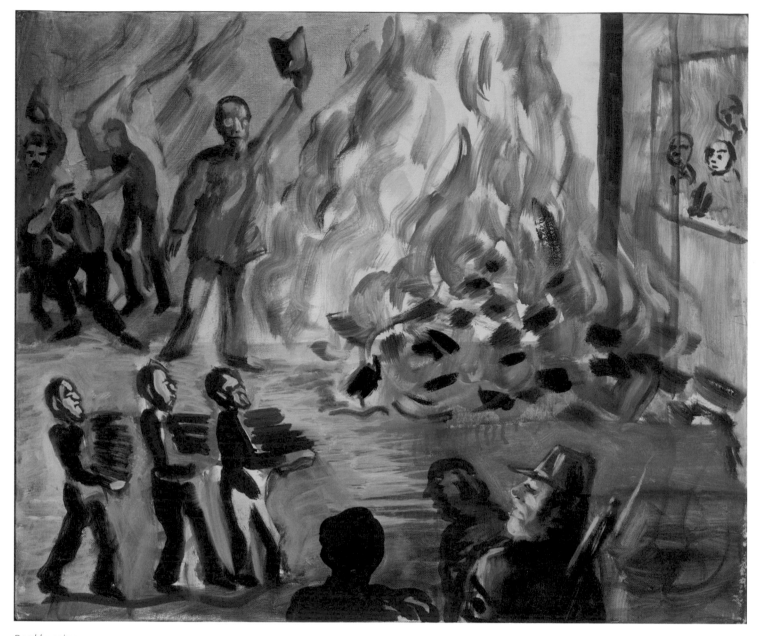

Bookburning
24″ x 20″
Oil on canvas
1983
Private Collection

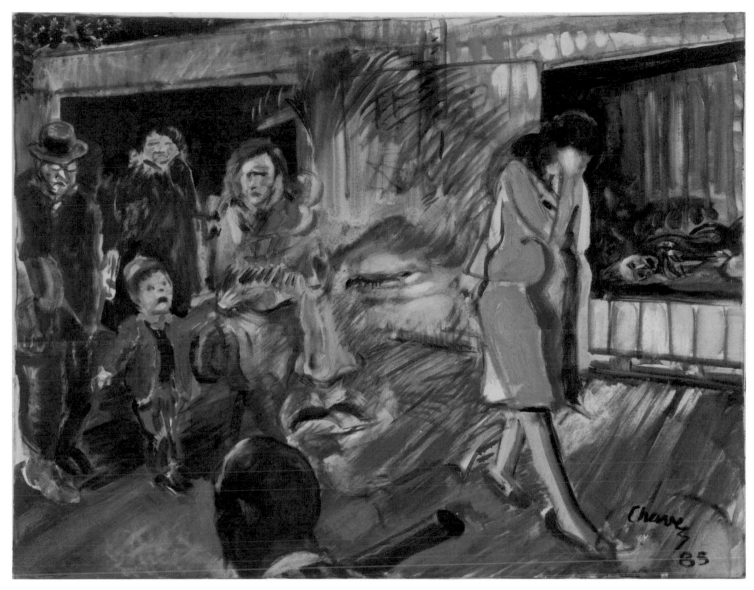

The Poet Remembers
30″ x 24″
Oil on canvas
1984

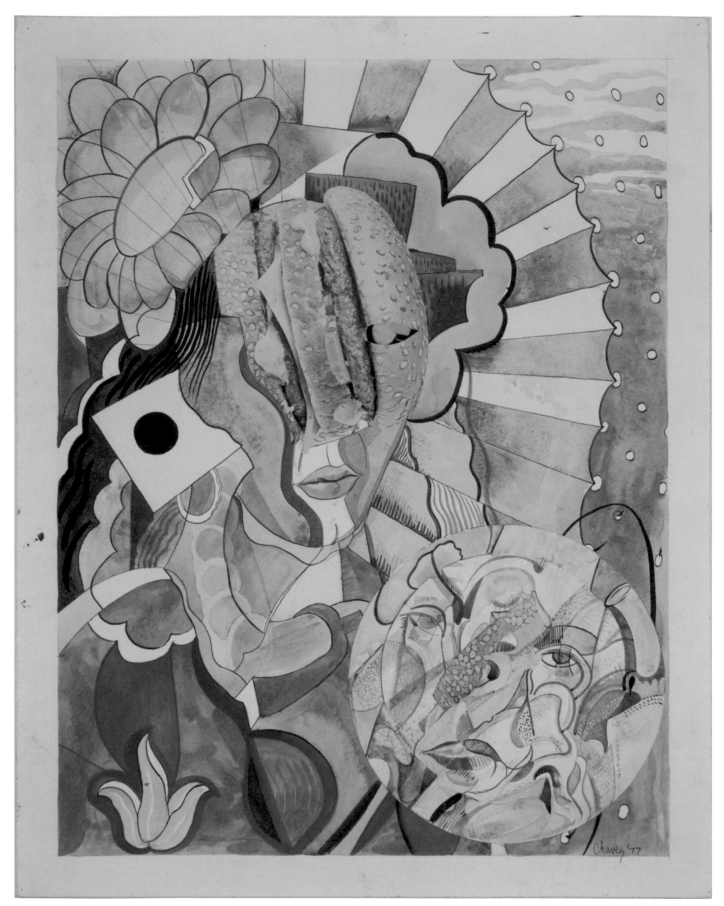

Madonna
16¹¹/₁₆″ x 21¹¹/₁₆″
Watercolor, collage
1980

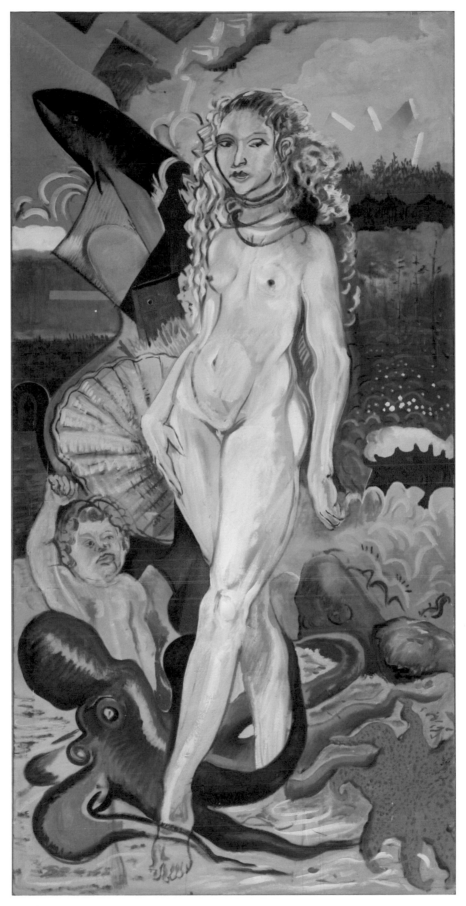

North Coast Venus
36" x 72"
Oil on canvas
1984
Private Collection

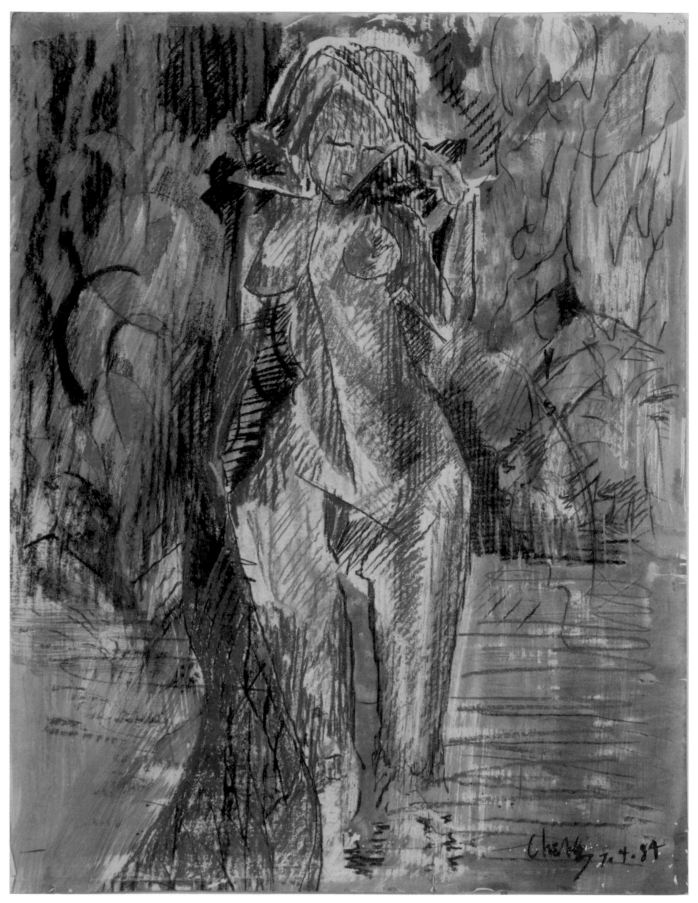

Figure Study

23″ x 29⅞″

Water-soluble crayon

1984

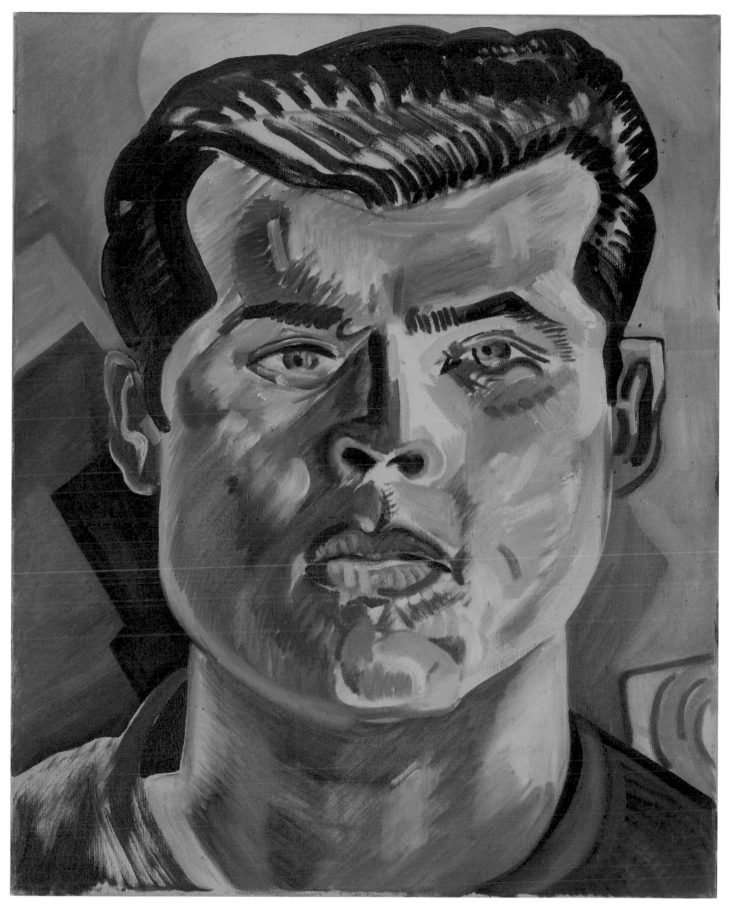

Portrait of Gilbert Lujan
16" x 20"
Oil on canvas
1966
Private Collection

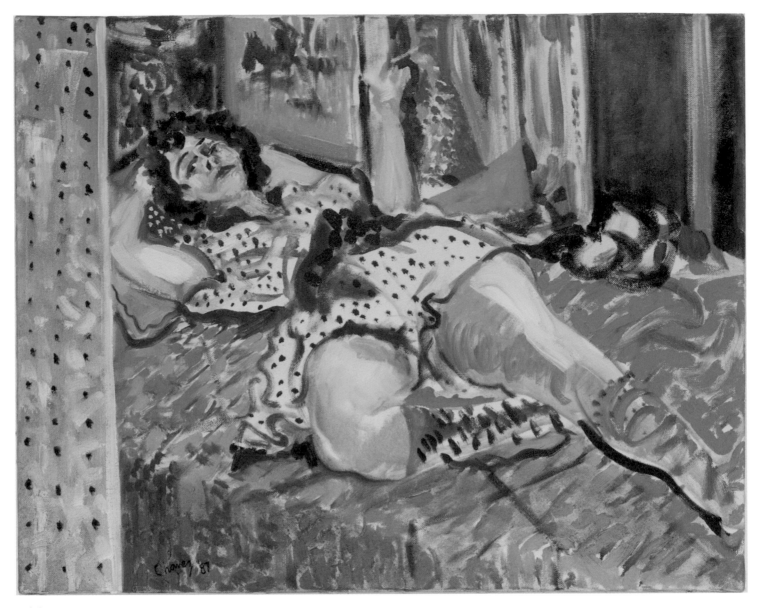

Odalysque
20″ x 16″
Oil on canvas
1986
Collection Jessica Evans

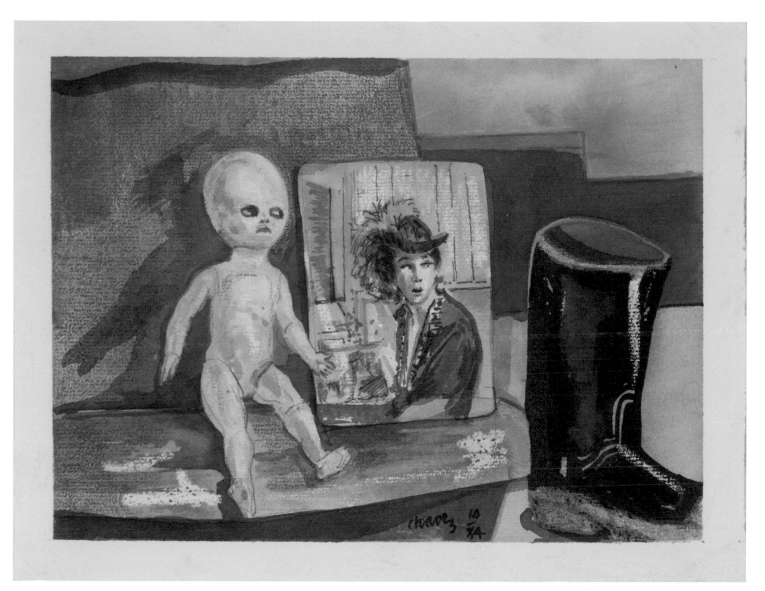

Still Life with Doll and Meryl

11¹/₁₆″ x 8¹¹/₁₆″

Pen and ink, watercolor

1984

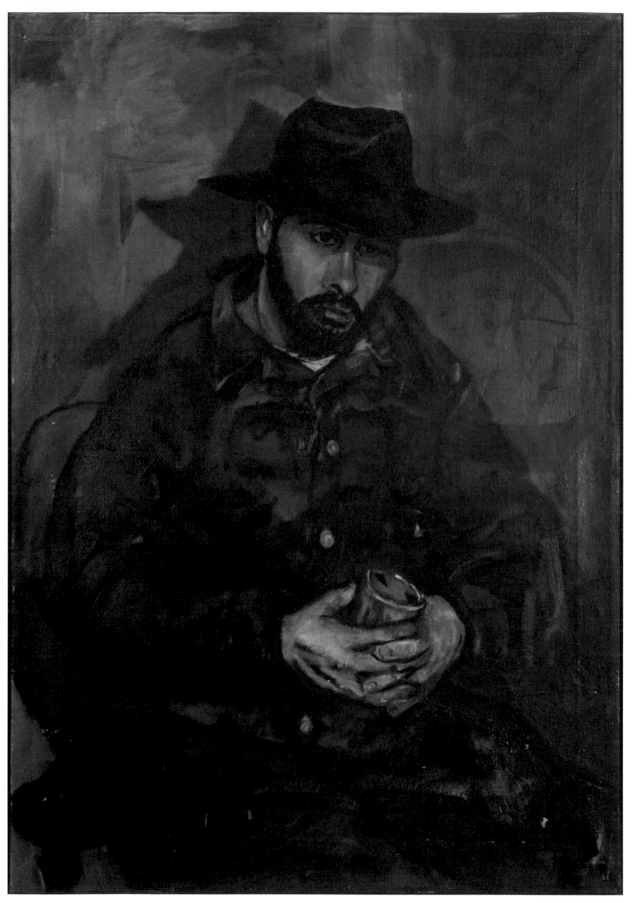

Portrait of the Artist's Brother Raul
24⅛" x 34"
Oil on canvas
1959

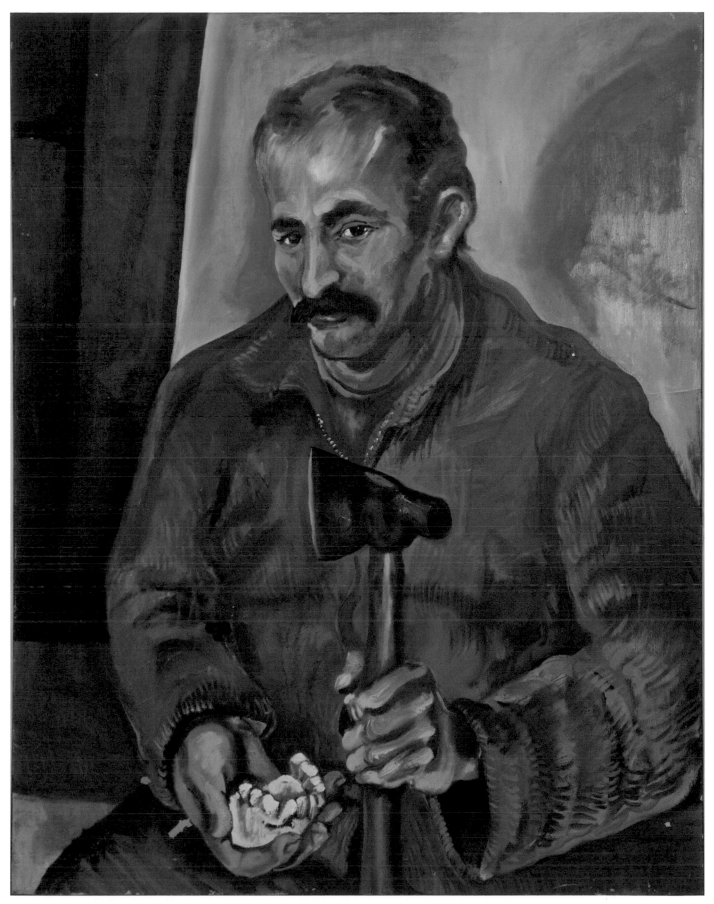

Garabedian with Hatchet

30" x 39"

Oil on canvas

1965

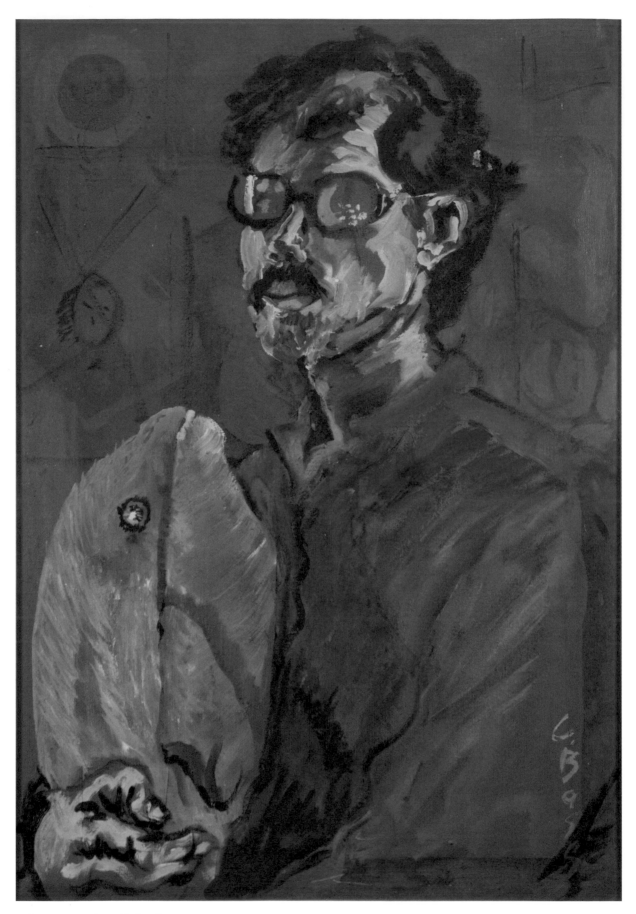

Self Portrait with Stuffed Fish
22" x 32"
Oil on Canvas
1983

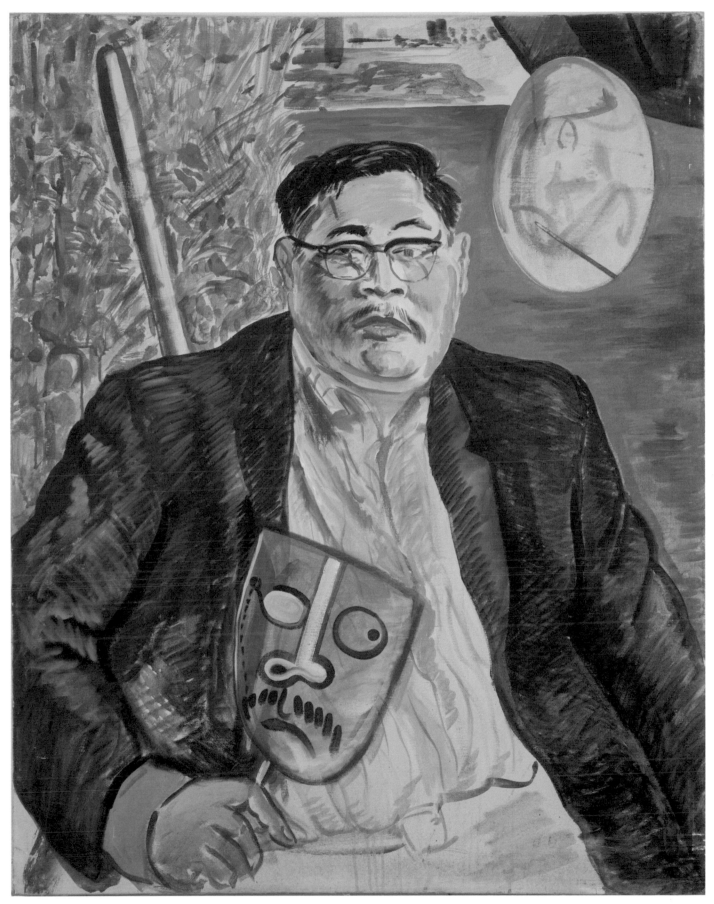

My Buddhist Friend Sam C.

37¼" x 47½"

Oil on canvas

1972

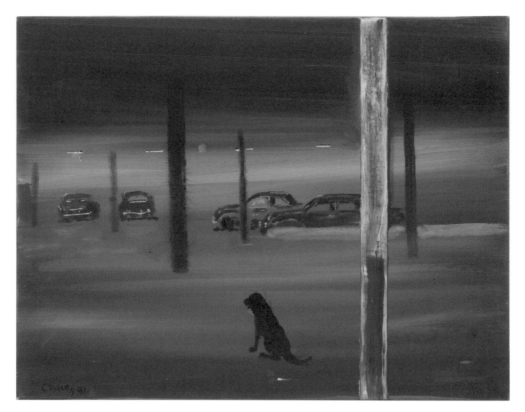

Parking Structure
14" x 11"
Oil on canvas
1991

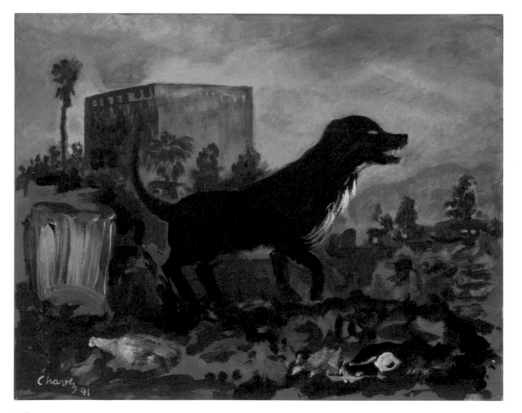

Bill
14" x 11"
Oil on canvas
1991

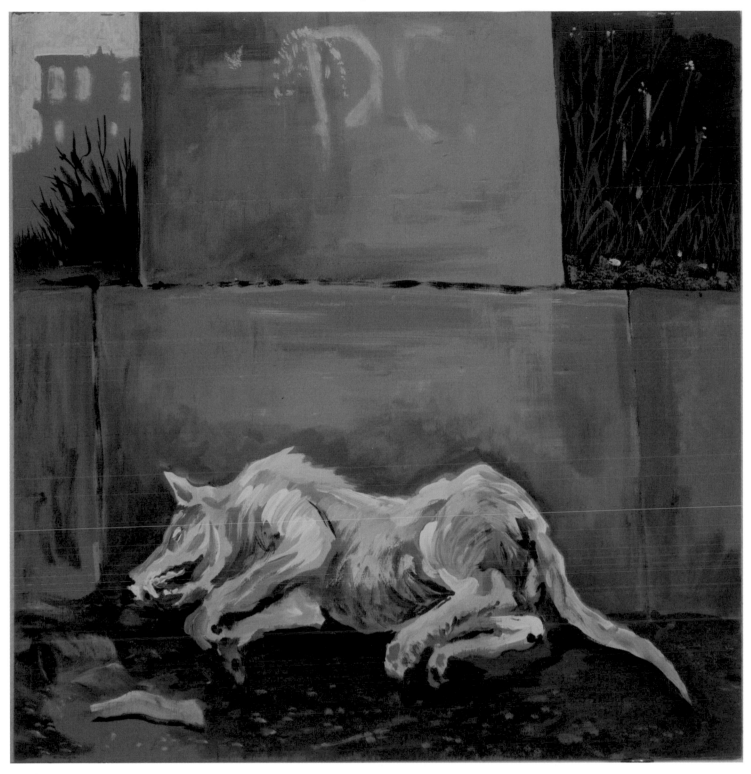

Dead Dog, L.A. Freeway
24″ x 23⅞″
Acrylic on panel
1992

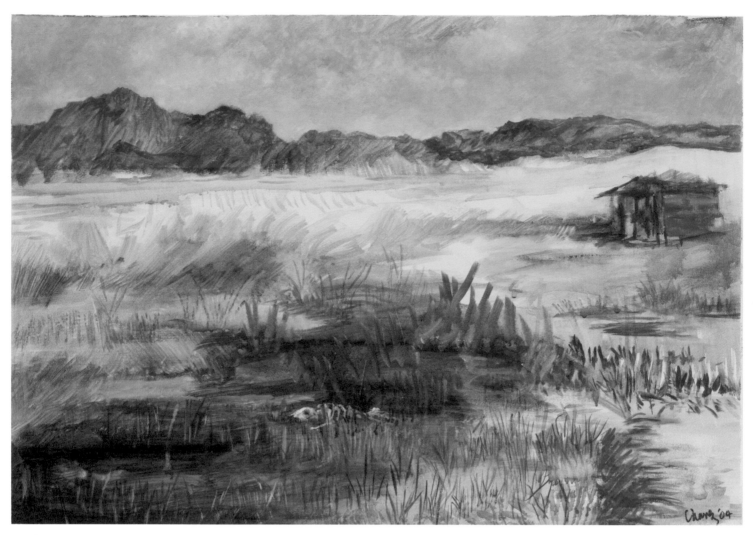

Landscape
28⅛" x 19⅞"
Oil on canvas
2004

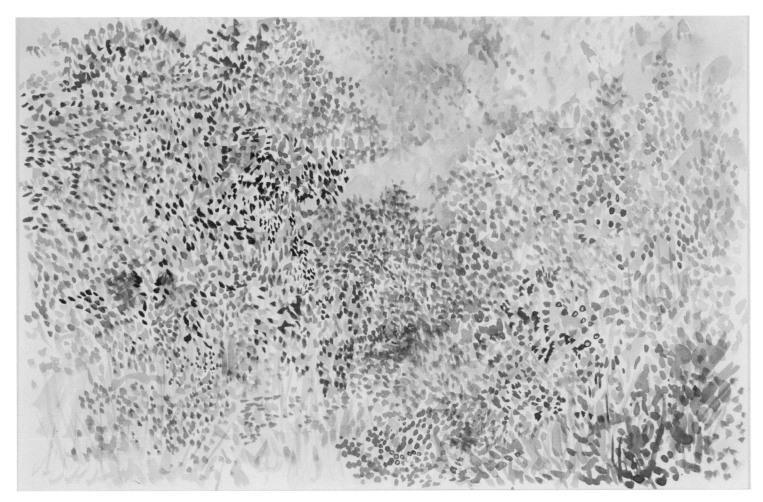

Late Summer
17¾" x 11⁹⁄₁₆"
Watercolor
2007

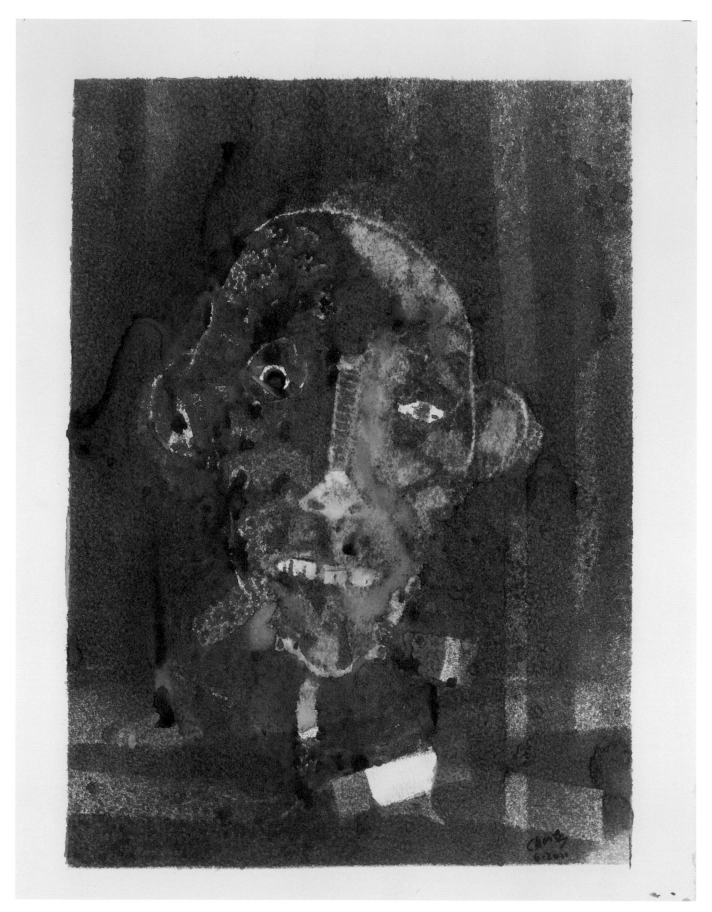

Anticipation
18" x 25½"
Watercolor
2011

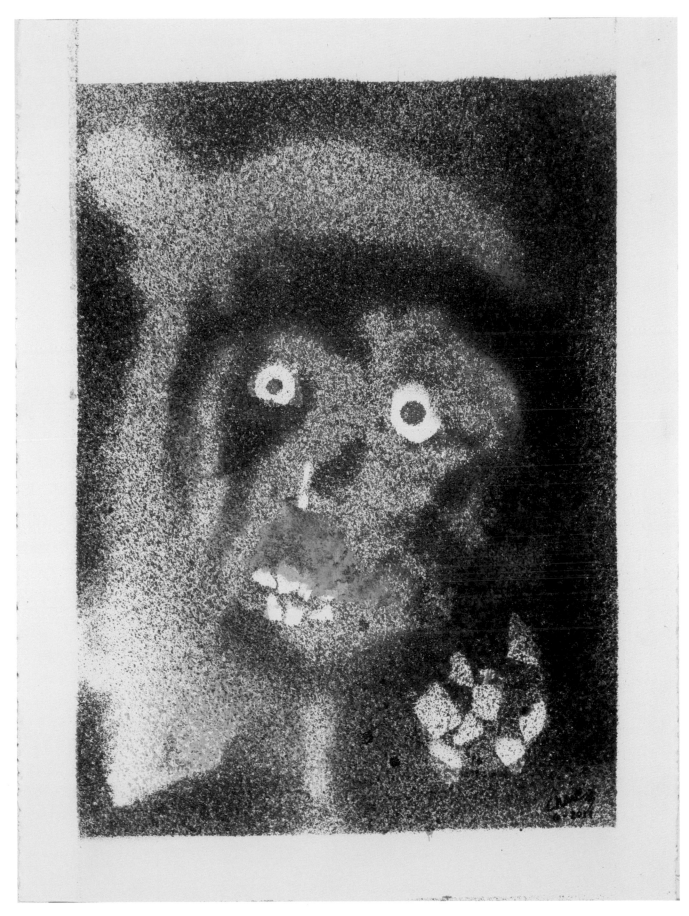

Fear
18″ x 25½″
Watercolor
2011

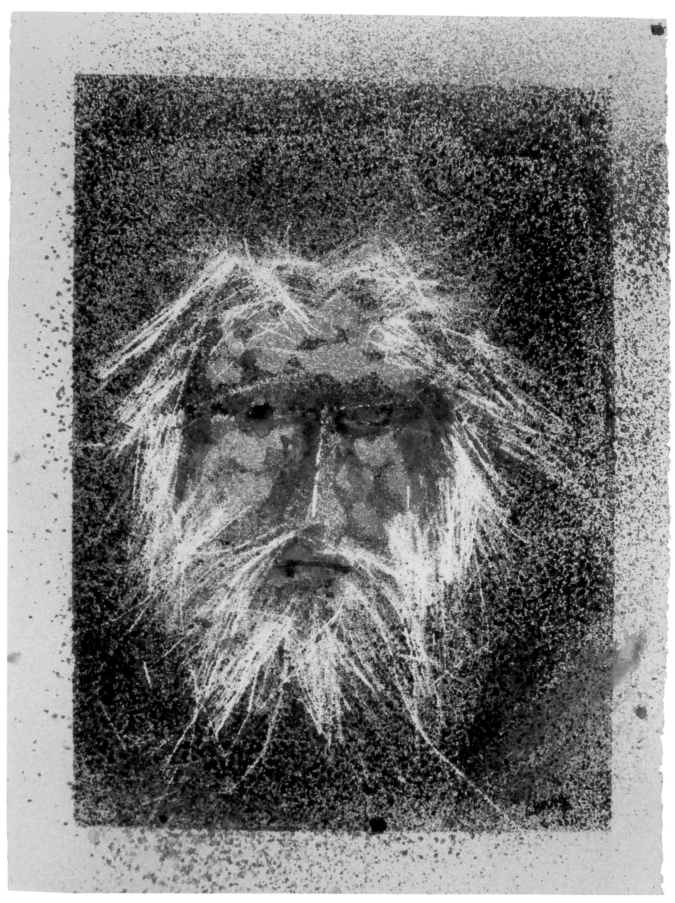

Larry, the Mad Hatter
18″ x 25½″
Watercolor
2011

84

List of Reproductions

Biographical Timeline

Roberto Esteban Chavez

Note: All events, institutions, and venues cited here, unless otherwise specifically described, have the Greater Los Angeles, California area as their locale.

Birth

August 3, 1932, Los Angeles, CA

Education

1949–52	Los Angeles City College (LACC)
1955–61	University of California at Los Angeles (UCLA), B.A., M.A., Pictorial Arts
1962–63	California State University (CSU), Los Angeles, Standard Teaching Credential; Art Major, English Minor

Military Service

1950–54 Korean Era Veteran. United States Naval Air Reserve 1950-54. Active duty 1952-54 United States Naval Air Station, Los Alamitos. Served as Photographer's Mate. Honorably discharged October 1954.

Teaching Experience

1960–69	UCLA Extension, part time
1969–81	East Los Angeles College, full time
1991–94	Part Time

Rio Hondo Community College
Southwest Community College
Arts in Corrections
College of the Redwoods
East Los Angeles College
Santa Monica City College
Pasadena City College
East Los Angeles College (ELAC) Evening Division
Los Angeles Trade Tech
UCLA Extension
UCLA Art Department Teaching Assistant

1994–2008 Arts in Corrections, California Department of Corrections, full time

Guest Lectures

California State University
Loyola-Marymount University
University of California, Santa Cruz, CA
Citrus College, Glendora, CA
California State University, Long Beach, CA
Marianna Avenue Elementary School
Mendocino Elementary School, Mendocino, CA
Fort Bragg High School, Fort Bragg, CA

Chronology

1932 Born in Los Angeles to Jose Salazar Chavez and Esther Avila, emigrants from Zacatecas, Mexico; the ninth of twelve children

1938 Enrolled in public schools: Marianna Avenue Elementary, Belvedere Junior High; James A. Garfield High School

1949 [June] Graduated High School. Enrolled as commercial art major at Los Angeles City College

1950 [June] Enlisted in U.S. Naval Air Reserve. Training as Photographer's Mate

1952 [July] Called to active duty. Served at U.S. Naval Air Station, Los Alamitos, CA

1954 [Oct] Honorably Discharged. Reentered LACC. Transferred to UCLA

1959 [Jan] Graduated with B.A. in Pictorial Arts. Accepted to UCLA Graduate School
[Sept] Awarded Teaching Assistantship; taught lower division classes

1960 [Oct] Jerry Wald Award for Commercial Design

1961 [June] Graduated, M.A. in Pictorial Arts; Graduate Master's Exhibit; awarded UCLA Graduate Fellowship; traveled across U.S.
[Sept] On return to Los Angeles, worked as production line painter for Artcraft Frame and Picture Company

1962 [Jan] Group show: *Drawing Invitational*, Louisiana State University Galleries, Baton Rouge, LA
[Feb] Began teaching for UCLA Extension, classes in Drawing, Life Drawing and Painting, and classes for gifted children from 1962-67
[June] Group Show: *Four Painters*, Ceeje Galleries
[Aug] Group Show: *Mt. Sinai Benefit Exhibit, First Annual Invitational*, Sears Building, Westwood, CA
[Nov] One Person Show: *Recent Paintings*, Ceeje Galleries
[Dec] Group Show: *Gallery Artists*, Ceeje Galleries
[Dec] Group Show: *How Prints Look*, Vincent and Mary Price Gallery, ELAC

1963 [June] Completed work for California Teaching Credential at CSU, Los Angeles
[July] Group show: *Ten Sculptors*, Ceeje Galleries

1964 Group Show: *Six Painters of the Rear Guard*, Ceeje Galleries
[June] Served as Art Coordinator for Lake Arrowhead October Conference Center through University Extension, UCLA

1965 [June] One Person Show: *Paintings*, Ceeje Galleries
[June] Group Show: *Third Annual Invitational of Contemporary Art*, Westwood, CA

1966 [Jan-June] Directed Teen Post for E.Y.O.A., Pacoima, CA
[Sept] One Person Show: East Los Angeles Skill Center, Monterey Park, CA
[Sept] Traveled through Baja California with Eduardo Carrillo to help establish the Regional Arts and Crafts Center, La Paz, Mexico

1967 [June] One Person Show: *Paintings*, Theodore Off Estate, Westwood, CA

[Sept] Traveled to New York for a book illustration commission; painted mural *The Astrological Signs* for Ketti Frings, CT

[Sept] Selected as demonstration artist for *Artmobile: Art for the Inner City Schools*, Los Angeles Unified School District; visited ten targeted inner city schools with portable exhibit and mural painting demonstration

[Sept] Group Show: *Artmobile traveling exhibit*, L.A. City Schools

[Oct] Worked as animator-designer for Churchill Films, Los Angeles on four educational films; produced one script on the Chicano movement; featured in the film *Kite Story*

1968 [Sept] Consulted on the development of Third World Unit, UCLA Film School

[Sept] Group Show: *Reflections*, Artmobile #2, L.A. City Schools

[Sept] Group Show: *Pocho Art*, California State University, Long Beach, CA

[Oct] One Person Show: Onion Gallery, Northridge, CA

1969 [Jan] Began teaching full-time at East Los Angeles College; double assignment in Art and Chicano Studies; developed new courses in Mexican Art, Pre-Columbian Art, Chicano Literature, and *Teatro*; Faculty Sponsor for *La Vida Nueva* student paper

[May] With Louis Lunetta and others organized the ELAC Inflatable Art Festival

[Sept] Group Show: *Chicano Art*, Whittier College Semana de la Raza

[Sept] Group Show: *El Arte del Pocho*, Citrus College Galleries

1970 [May] Group Show: *Pocho Art*, CSU, Northridge

[June] Group Show: *El Arte de la Raza*, Santa Ana College Gallery

[Sept] Painted three-story mural facing parking lot, Alice's Restaurant, Westwood, CA

[Oct] Group Show: *Chicano Art*, Rio Hondo Regional Library, Montebello, CA

1971 [Sept] Assumed Chairmanship of Chicano Studies Department, ELAC; obtained District funds for mural project as part of course in Barrio Art and Traditions

1972 [May] Painted portable murals for Cinco de Mayo, ELAC; painted mural on the Boy's Gym facade at Belvedere Junior High School in East Los Angeles

[Aug] Painted Mural *Porque se Pelean?* on Simmons Roofing Building in East Los Angeles as part of the Street Mural Project of the Los Angeles Department of Parks and Recreation.

[Sept] With student help painted mural *La Fiesta* in Estrada Courts, Los Angeles Housing Authority, East Los Angeles

1973 [Nov] One of five artists selected for the TV program *Chicano Supergraphics*, Channel 28, Los Angles; this video was included in the first Chicano exhibit at the Los Angeles County Museum of Art

1974 [May] One Person Show: Santa Monica College Art Galleries, Santa Monica

[Apr] Awarded one of five Los Angeles Community College District Grants for Educational Development with a mural proposal

[Sept–Nov] Painted mural on the facade of Ingalls Auditorium at ELAC; this mural, titled *The Path to knowledge and the False University*, measured 200 feet by 35 feet

1975 [May] One Person Show: *Paintings*, University of California, Irvine

[June] Group Show: *Chicano Art*, Capitol Building, Sacramento, CA

[Sept] Group Show: *Chicanarte*, Los Angeles Municipal Art Galleries

[Nov] Group Show: *Governor's Choice*, ELAC Art Galleries

1976 [May] Painted mural *Chicanos in Space* for the employees' cafeteria at Aerospace Corporation in Redondo Beach, as part of Spanish American Heritage Month

[June] One Person Show: The Artery Contemporary Art Gallery, Van Nuys, CA

1977 [Mar] One Person Show: *Paintings and Watercolors*, Mechicano Art Center

[Apr] Group Show: *Los Four Plus One*, Claremont College, Claremont, CA

[July] One Person Show: *Summer Stuff*, paintings and watercolors, Loyola-Marymount University

[Nov] Group Show: *El Dia de los Muertos*, Mechicano Art Center

1978 [Jan] Group Show: *Paintings and Drawings*, Frederick Wight Galleries, UCLA

[Mar] One Person Show: *Paintings and Drawings*, Uptown Gallery, Fort Bragg, CA

[Apr-July] Opened and Co-Directed (with Sybil Venegas) the Eastlos Gallery, a non profit community art space in East Los Angeles; Featured in that space were the *Pachuco Show* of Jose Montoya and the mural-sized works of Eduardo Carrillo

[June] Group Show: *Faculty Show*, Santa Monica College Gallery

[Oct] One Person Show: Vincent and Mary Price Gallery, ELAC

[Dec] One Person Show: *Paintings and Sculpture*, Uptown Gallery

1979 [Summer] ELAC mural *The Path to Knowledge* painted out by the order of the college administration

[Nov] Group Show: A.M.A.E. State Conference exhibit, Hyatt Regency Hotel, Los Angeles

1980 [May] Painted two portable murals, *Chingazos en Puebla* and *The Third World War*, for the Cinco de Mayo Exhibit of Chicano Art, Loyola Marymount University

[Oct] Group Show: *The Mask: Object and Image*, Old Venice Jail Gallery, Venice, CA

1981 [Feb] Group Show: *Three Schools, Three Views*, Pico Rivera Art Center, Pico Rivera

[May] Group Show: *Conceptions*, Old Venice Jail Gallery

[Apr] Group Show: *Califas*, an exhibition of Chicano Artists

in California, Mary Porter Sesnon Art Gallery, College Five, University of California, Santa Cruz

[July] Group show: *Hecho en California – Made in California*, Sala de Exposición, Guanajuato, Mexico

[June] Resigned position at ELAC, moved to Fort Bragg, CA

[Sept] Two Person Show (with Betty Lane Gwinn): Jughandle Farm, Caspar, CA

[September] Instructor in Drawing and Painting, College of the Redwoods Educational Center, Fort Bragg, CA

1982 [Apr] Video: *The Execution*, a mural presentation on videotape produced for the Califas Art Conference at UC Santa Cruz

[Sept] Two Person Show (with Betty Lane Gwinn): *Raw Fish*, paintings and drawings, Winona Studio of the Mendocino Art Center, Mendocino, CA

1983 [Mar] One person Show: *Paintings*, Berkeley Art Center, Berkeley, CA

Book illustrations for *Mex Glimpse*, poems by Paul Tulley, including logo design, hit & run press, Fort Bragg, CA

[Apr] Group Show: *Ceeje Revisited*, Municipal Art Galleries, Los Angeles, CA

[Apr] One Person Show: *Paintings*, Lelia Ivy Gallery, West Los Angeles, CA

[Aug] One Person Show: *Works on Paper*, Winona Studio, Mendocino, CA

[Sept] Instructor in painting, College of the Redwoods, Fort Bragg, CA

1985 [Jan] Group Show: *Statements*, Mendocino Coast Campus Art Faculty, College of the Redwoods Gallery, Eureka, CA

[Oct] One Person Show: *The Judgment of Paris*, paintings on a classic theme set in Auschwitz, Fiddler's Green Bookstore, Fort Bragg, CA

1986 [May] As a visiting art teacher at Northcoast High School, Fort Bragg, CA, worked with students to produce a 10 foot by 30 foot library mural

[Sept] One Person Show: Fiddler's Green Bookstore

1987 [Sept] One Person Show: *Paintings on a Circus Theme*, Fiddler's Green Bookstore

[Oct] *Free Circus* mural displayed at Mendocino County Fair, Boonville, CA

[Nov] *Kitchen Suite* oil paintings installed at Lu's Kitchen, Fort Bragg, CA

[Dec] One Person Show: *Paintings*, Northcoast Artists Gallery, Fort Bragg, CA

1988 [May] Guest Lecturer, UC Santa Cruz Art Department, College Five; One Person Show: *Paintings*, Faculty Gallery, College Five, UCSC

[June] One Person Show: *Kassner Sonata – Oil Paintings*, Molfino's, Fort Bragg, CA

[Sept] Group Show: *4 Artists*, What's Afoot Gallery, Caspar, CA

[Oct through Mar 1990] Teacher, Latchkey Art Program, Mendocino County Schools

1989 [Mar] Guest Lecturer, Fort Bragg High School Murals in the Schools Program, Fort Bragg, CA

[Nov] Group Show: *Artists Who Teach on the Mendocino Coast*, Fort Bragg Center for the Arts, Fort Bragg, CA

1990 [Mar] One Person Show: *Adios Fort Bragg: 10 Years Retrospective - Paintings and Drawings*, What's Afoot Gallery, Caspar, CA

[Aug] Workshop Speaker, *Art Exchange*, Municipal Art Gallery, Barnsdall Park, Los Angeles, CA

[Oct] Artist in Residence, Montebello Unified School District, Montebello, CA

[Nov] Group Show: *Dia de Los Muertos*, Seventh Annual Exhibit, Los Angeles Photography Center

1991 [Sept] Began teaching at Rio Hondo, Whittier; and ELAC and Southwest College

1992 Began teaching for Artsreach, mainly at California Rehabilitation Center and Chino prisons, California Department of Corrections (CDC);

Obtained California Arts Council grant as Artist in Residence for Arts In Corrections (CDC)

1994 Artist Facilitator at Chuckawalla State Prison, Blythe, CA (CDC)

1994 Transferred to Valley State Prison For Women, Chowchilla, CA (CDC)

2009 Retired, moved to Arizona

2011 [Oct] Group Show: *Art Along the Hyphen: The Mexican-American Generation*, Autry National Center Museum, Los Angeles; a component of the Getty Foundation's Pacific Standard Time initiative.

2012 [Sept] Book: *Roberto Chavez: Drawings and Paintings*, published on the occasion of a major traveling exhibit beginning at the Robert F. Agrella Art Gallery of Santa Rosa Junior College, Santa Rosa, CA; and continuing in January 2013 at Wiegand Gallery, Notre Dame de Namur University, Belmont, CA

[Nov] One Person Show: *Roberto Chavez, Painter*, Robert F. Agrella Art Gallery of Santa Rosa Junior College, Santa Rosa, CA

2013 [Jan] One Person Show: *Roberto Chavez, Painter*, Wiegand Gallery of Notre Dame de Namur University, Belmont, CA

Roberto Chavez: Paintings and Drawings
Typeset in Minion, with Gill Sans titling and Formata captions
Printed on 100# Pacesetter Matte Book and 110# Pacesetter Matte Cover

Design and Typesetting, Colored Horse Studios
Reproductions Photography, Calvin Lee and Nicholas Wilson
Color Correction, Anatol Chavez
Printing, Biss Printing, San Francisco
Bindery, smythe-sewing and paperback, Roswell Bookbinding, Phoenix, AZ
Bindery, hard cover and slipcases, Arnold Martinez, South San Francisco

First edition
Smythe-sewn paperback: 1,250 copies
Smythe-sewn hard cover: 250 copies,
of which 100 copies available in slipcases, signed by the artist

hit & run press
1563 Solano Avenue, #379
Berkeley, California 94707

Janet and Roberto at home in Arivaca, Arizona, 2012

Photo: Robert Ross